PRAISE FOR SELLING ART 101

Aloha Robert, I love your book! If I had written a book like this, I would be helping artists reach their highest level. It is simply the best art sales manual I have ever read. It is a bible for me now. I am a moderately successful artist in Kauai. I make over $150,000.00 a year. My sales were really down due to a bump in the road. The first day I perused your book I sold $1400, the second day $1200, and the third day $1440 at an outdoor show. Thank you so much. *Dawn Lundquist*

Thank you very much for putting this book together. It is just what I'd been looking for. The practical guidance you offer and examples you provide have helped me gain confidence in selling my artwork. I really like the realistic approach of the book; it is something I can relate to and put to use with ease. *O McRae*

A week after attending Robert's class, I sold a record amount of artwork out of my studio, and did so with more confidence and satisfaction than ever before. *Andrew Leone*

Selling Art 101 gave me tools to deal with my discomfort and shyness about selling my artwork during open studios. *Nancy Russel*

SELLING
ART 101

SECOND EDITION

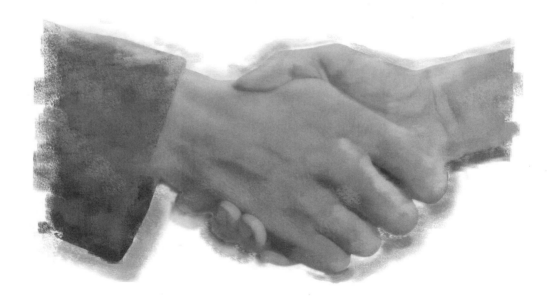

BY ROBERT REGIS DVORÁK

Art Network

SELLING ART 101, SECOND EDITION
THE ART OF CREATIVE SELLING

Second Edition August 2009

Copyright ©2009 by Robert Regis Dvorák

Cover and layout by Laura Ottina Davis
Sketches throughout book by Robert Regis Dvorák

Published by ArtNetwork, PO Box 1360, Nevada City, CA 95959-1360
530.470.0862 www.artmarketing.com

ArtNetwork was created in 1986 with the idea of teaching fine artists how to earn a living from their creations. In addition to publishing art marketing books, ArtNetwork also has a myriad of mailing lists—which we use to market our products—available for rent. Visit our website for details.

The author, Robert Regis Dvorák, may be contacted at PO Box 370371, Montara, CA 94037
Studio: 650.359.1288 Office phone and fax: 916.391.5051 www.youcreate.com robert@youcreate.com

Dvorák, Robert Regis

 Selling art 101 : the art of creative selling / Robert Regis Dvorák. -- 2nd ed. --
 Nevada City, CA: ArtNetwork, 2004.

 p. ; cm.
 (101 series)

 Includes index.
 ISBN: 0-940899095-5 978-0-940899-96-4

 1. Art--Marketing. 2. Art--Economic aspects. 3. Selling. I. Title.

N8600 .D86 2004
706/.8/8--dc22 0404

Disclaimer: While the publisher and author have made every reasonable attempt to obtain accurate information and verify same, occasional address and telephone number changes are inevitable, as well as other discrepancies. We assume no liability for errors or omissions in editorial listings. Should you discover any changes, please write the publisher so that corrections may be made in future printings.

Printed and bound in the United States of America

Distributed to the trade in the United States by Consortium Book Sales and Distribution

FOREWORD

If you have decided to go into the business of making your living from the sale of your artwork, learning the techniques in this book is a must. Without this information, you might make a few sales, but more than likely, you'll miss a lot more!

Learning sales skills does not happen overnight. You must practice and break through some personal roadblocks. You must believe in your work without waivering. When I took Robert's class through The Learning Exchange in Sacramento, California, I could see by the role-playing exercises we engaged in as students that all of us had a lot to learn and overcome regarding attitudes about art sales. I also learned that many of the artists did not have even the simplest of marketing skills, let alone sales skills.

Not only must you read this book, but you must reread and practice, again and again. Try to make the exercises in this book part of your life. As explained in Chapter 4, you want to reach the fourth skill level: Have selling techniques become a natural habit.

Make this book your friend. Fray the edges. Write in it. Mark it up. Put Post-it notes where you need them. After all, it is essentially a workbook.

With the other books in the series—*Art Marketing 101, Art Office, Art Licensing 101, Internet 101,* and *Power Up with PR*—artists can no longer complain about not knowing how to approach their career. All the help a fine artist needs is right in front of you. You simply need to follow through, take your life into your own hands and proceed with an attitude of success. You will be surprised at what awaits you around the corner.

Rereading this book as editor its second time around made me appreciate what a great book it is—chock full of very specific examples and advice. It's a book to be read and reread, studied and practiced. Truly, all artists need this book if they want to have a successful career selling their art.

Constance Smith
Author of *Art Marketing 101*

How this book came to be

When I made the decision to make my living as an artist, I had no idea that I was beginning a long educational program that would result in many disappointments and frustrations, as well as victories and successes. In those beginning years, I used to have an open studio every December for the purpose of selling current work. Before I had a real studio, I would have my open studio in my home. I would move aside the furniture and turn my home into an art gallery. We had nice hardwood floors in the duplex we were living in, and it was not difficult to transform the lower floor into a gallery with my paintings on the walls and tables. I had a guest book, and I sent out invitations to a select list of people. My thinking was that December was a good time to have an open studio because people were looking for special gifts to give their family and friends at Christmastime. I always had moderate success.

After a few years went by, I "graduated" to a commercial studio space. My first open studio at this location was to be a special event. I had a catering service deliver food. I served wine and kept my studio open all weekend. I thought that I had done everything right. I sent out invitations to all of the people on my mailing list. The weather was perfect.

At the end of this open studio, when I took account of all the sales that had been made, I found that my returns were very disappointing. Although I was confident that my new artwork was of the highest quality and had great appeal, I had sold very little. A friend of mine, hearing of my frustration, handed me a tape by the nationally known sales trainer Tom Hopkins. The title of the tape was "How to Handle Failure and Rejection." After listening to this tape, I got very excited about the material and asked my friend if he had more tapes by Tom Hopkins. My friend gave me another tape, and then another and another. Eventually I listened to every tape in this album, which was titled "How to Master the Art of Selling Anything." I was very naive at that time in my life. I had no knowledge about selling and didn't think it was necessary to have sales training in order to sell. My naiveté turned into excitement as I studied this material as well as other material offered by other sales trainers.

After tailoring the sales techniques to the business of selling art, the sales of my own artwork increased exponentially. I also realized that this material would be helpful to anyone who would like to learn to sell art. I then created a one-day workshop for artists and art dealers, which I called "The Art of Selling Art." That was the beginning.

Since then, as an art sales consultant, I have presented lectures and many one-day seminars on the subject of selling art. I have also worked with numerous art galleries and individual clients offering art-focused sales training to artists, gallery staffs and art representatives.

After Constance Smith, the owner of ArtNetwork, took my seminar "The Art of Selling Art," she asked me if I would be interested in writing this book. I feel that this book together with her own book, *Art Marketing 101*, are an invaluable source of information for any person who wants to sell art.

Acknowledgements

I would like to acknowledge all of the people who have participated in the many workshops that I have presented for art galleries, universities, colleges and learning centers. Some of their comments are included in this book.

Table of Contents

CHAPTER 6 PHONE POWER

CHAPTER 7 LISTENING POWER

CHAPTER 8 CONNECTIONS

CHAPTER 9 CLOSING

CHAPTER 10 OVERCOMING OBJECTIONS

INTRODUCTION

More than a billion dollars are generated each year by art sales. Every year, many graduates of art schools enter the marketplace eager to make a name for themselves in the art world. Today, more people visit art museums than attend baseball games. We see art everywhere—in hotel rooms, lobbies, shopping centers, airports, private homes and gardens, corporate boardrooms, restaurants, hospitals, offices, parking structures and government buildings. Someone bought all this artwork. And someone sold it to them.

More than half a million people are involved in the art world, yet the transfer of a work of art is still a one-to-one business. As in all businesses, there are honest individuals and there are some shady characters with not much integrity. The business of selling art attracts extremely competitive individuals and people seeking fame and fortune. Many artists don't want to have anything to do with this competitive business, this commercial endeavor, and would just as soon stay tucked away in a safe studio working on their inspirations, waiting to be discovered.

Creativity, personal commitment and individual expression are the essence of the artist's soul. Artists must create art even if they have to give up creature comforts. They have no choice. An artist has a passion and a need to create. The making of art requires commitment and energy. So does the selling of art. If you are an artist who wants to sell your work, or if you are a person who wants to sell other people's artwork, maintain the highest integrity. Be professional in your selling endeavors. Use the material in this book to bring something precious—art, and the appreciation of art—to the world around you.

WHAT THIS BOOK IS ABOUT

This book is about the business of selling art, face to face, eyeball to eyeball. For most people, the skill of selling art needs to be learned.

If you study the methods provided in this book, you will find that the approach to selling that I recommend is a gentle one. People love to buy art. People love to own art. Art enriches people's lives. Art can transform consciousness. The artwork displayed in a home will influence the lives of the people who live in that home.

Do not think that I am going to give you a series of techniques that will trick people into buying art. Assume that the people who are interested in the work you are selling would like to own it. I want to assist you in giving people the opportunity to own what they already know they want.

WHOM THIS BOOK IS FOR

Being an artist is exciting. An artist exercises personal creativity and offers it to society. But an artist must also learn the business of being an artist. The great artists who became successful in their lifetime did that. The making of the art is the production department. Then there are the marketing, advertising, public relations, publicity, human resources, sales, accounting and bookkeeping departments. An individual artist deciding to go into business must see that all these tasks are taken care of in order to be successful. Some successful artists have made lucrative arrangements with art galleries to handle much of this work.

Most artists would prefer to have an art dealer or representative sell their work. It's been my experience, however, that an artist who can sell his or her own work is much more desirable to an art gallery or an

Chapter 1
Preparing for the Marketplace

Making a commitment

Preparing to sell

Prospecting

The three P's

Overcoming roadblocks

The payoffs

Business cards

Pricing work

If you aren't going to go all the way, why go at all?
Joe Namath

MAKING A COMMITMENT

As an artist, you are probably passionate and very individualistic, have strong personal views, notice things that seem to go unnoticed by others; you dream, you visualize. You are sensitive and idealistic and may be considered a little crazy by others. You love to create! And, if you are like me, you have trouble balancing your checkbook.

BODY OF WORK

If you are an artist who wants to sell your work, you need to have a body of work—a number of paintings, prints, sculptures. A minimum of 12 to 20 pieces that look like they were done by the same person, are all about the same size, are all in the same medium, are all completed, and have a contextual theme. Don't even attempt to go to an art gallery in search of representation unless you have that many consistent pieces. Do not take an assortment of media and subject matters to a gallery, thinking that you will impress the gallery owner by your wide range of talent and skill. The work that you show must be of the highest caliber—only your very best work. Don't risk showing second-rate work.

Think of the painters and sculptors who are well known—Georgia O'Keeffe, Mark Rothko, Willem De Kooning, Robert Rauschenberg, Helen Frankenthaler, Henry Moore, Andy Warhol, Alberto Giacometti, JMW Turner. Each artist's work has unique subject matter, is consistent in medium, and has a contextual theme.

Art dealers are looking for new work. Do not imitate the successes of others. If a dealer or critic sees a resemblance to another artist, you will not be welcome. You may borrow knowledge and information, but you must do your own work.

Making a commitment in writing reinforces that commitment four-fold. Constance Smith

When you have a body of work and feel prepared psychologically to sell, be very discriminating. Pick your best, most original and creative work and go for it!

▸ Be sure that you are willing to sell the artwork you create. Ask yourself: Are you willing to have someone else take possession of these pieces, knowing that you may never see them again? I have met many artists in my "Art of Selling Art" seminar who are not ready to let go of their work. If you have done some great work, work that surpasses anything else you have ever done, you may not be ready to see it sold. If you are in that situation, take the best (or your favorite two or three pieces) and keep them for yourself. Then let the others be put up for sale.

▸ When you are creating a new work, always say to yourself, "This work (painting, sculpture, print) is going to be for sale." When you know from the start that you will be letting it go, you will create with this in mind. As an artist, it is very easy to identify with your creative endeavors. They are like your children in some ways. You feel like they are a part of you. It can be hard to let them go to another home. It is psychologically easier if you know a work's destiny from the start.

▸ Know that you have a gift. Remember that you are offering the world something unique and personal. What you are selling is precious: it has come from your creative spirit. Whether you have been recognized or not, hold on to your personal vision and your self worth. The making of art is something that you must do. Even if no one ever sees your work, you are still creating it. If you want to sell your work, there are many suggestions in this book that will help you do that. As a fellow artist, I know with regard to the creating that I have no choice. With the selling of the art, however, I do have a choice.

The best way to process this information is to practice it a little at a time. Most importantly, you must have the attitude that you *can* sell art. As an artist, when I began selling my own work, it was scary, even terrifying. But as I became more knowledgeable about the process of selling, I found it easier and easier. The more success I had, the more my confidence increased and the process of selling became challenging and enjoyable. With success came a desire to learn more about the process. Begin the process of learning to sell art with an open and creative mind.

PREPARING TO SELL

Use your creative talents in the sale of your work.

I knew a man who saved up enough money so that he could paint in a studio every day for a year to develop a body of work. His work went through many transformations. He had some fine work at the end of this time, but he didn't think he was ready. Since he was out of money, he ended up getting a 9-5 job and never showed the work. Don't wait for perfection. When you think you might be ready, you are ready!

PROSPECTING

I find that the harder I work, the more luck I seem to have.
Thomas Jefferson

If you have only completed two or three pieces that you really like, you are not ready.

COLD CALLS

There are two kinds of cold calls—the incoming call from a potential new client and the outgoing call to someone you've never met.

The incoming cold call is the easier to handle. Someone who is interested in knowing more about the art you are selling calls you. The best way to handle this situation is to set up an appointment so that you can show the artwork. When you meet, you can apply the selling suggestions from this book.

The outgoing cold call is the more difficult. If you have had some experience making cold calls and feel comfortable doing that, I suggest you work that way. For most of us, however, making a cold call is difficult and often discouraging. I find that there are so many other ways of reaching out to clients that it is not necessary to do this kind of call.

WARM CALLS

I try to make what I call "warm calls" to people I've briefly met, people with whom I've had some previous contact, or people who have been referred to me by other clients. Each situation is different. Here is a list of people you might want to consider for your warm-call prospecting.

- ▸ Friends of friends
- ▸ Friends of people who have bought art from you
- ▸ Parents of the children with whom your children play
- ▸ Members of the clubs to which you belong: PTA, tennis, golf, book, bridge, gym
- ▸ Your neighbors
- ▸ Fellow office workers
- ▸ Your real estate agents or mortgage brokers
- ▸ People you meet in the art world
- ▸ Art gallery owners
- ▸ Participants in seminars you attend
- ▸ People you sit next to on planes and trains
- ▸ People you meet on cruise ships
- ▸ Artists and people working in the art business
- ▸ Anyone you meet

Contacts with any of these people could bring in sales. As you can see, they would not be cold calls but warm ones.

MORE IDEAS

▸ I have never done this, but I have met artists who have gone door to door in a neighborhood selling their artwork. They told me that they were successful in doing this.

▸ Painting on location. People will notice you and stop to inquire. If you are friendly with them, you can build rapport and eventually make a sale. I have sold quite a few paintings to people who have watched me paint on location. I know an oil painter who told me that every time she painted on location and there was a house in the painting, the owner of the house would come over to her and inquire if he could buy the painting.

▸ Have a private reception. Ask a friend or a friend of a friend with a lovely house in an upscale neighborhood to sponsor a reception for you with the purpose of displaying your work on a Saturday or Sunday afternoon. You display your art, and the house owner invites her wealthy friends to view your works. You meet these wonderful people, make friends, collect their addresses and phone numbers in your reception book. Even if they don't buy from you that afternoon, they are potential buyers for the future. Each of these people will also be a resource for other referrals. The house owner provides the display space, the food and the beverages. In exchange for this huge favor, you give the owner one of your original paintings. After the reception, you can call all visitors and ask for an appointment. If the homeowner is not receptive to this idea, ask for a referral. The key to this idea is to follow up with telephone calls to these individuals. For an artist who is just beginning, this is a wonderful way to launch a career. You will be surprised at how people will help, especially if they love the work.

MAINTAIN A WEB SITE

A prominent gallery owner told me that his web site is one of his most important business tools. It allows a person anywhere in the world to search for a particular artist's work and then contact the gallery. This is also true for an individual artist. Here are some suggestions for establishing and maintaining a viable web site.

▸ Keep it up to date.

▸ Keep it uncluttered and easy to navigate.

▸ Copyright every page.

▸ Display the images of the works in a small format with a click to the largest version possible.

> Remember, it is our attitude much more than our aptitude that will determine our success.

Ignorance is not bliss, it's
oblivion.
Philip Wylie

▸ When making a web site, display the artwork against a black background. It will accentuate the pieces. Remember last time you went to a jewelry store and admired a piece of jewelry displayed on black velvet? Black is a non-color. Any other color of background will alter the viewer's perception of the colors.

MAIL NEWSLETTERS

People who like your work will be pleased to receive your newsletter. You can send out a newsletter as a hard copy in the mail or via an e-mail. Since an e-mail newsletter is free, it is not necessary to send it out with any regularity unless you want to. When people come to your gallery or studio, be sure to have them leave their e-mail information if they are interested in receiving news or updates.

SEND OUT INVITATIONS

Sending out invitations can be expensive when your mailing list gets into the thousands. Try to maintain a good list of people you are sure want to receive the information and actually might come to an art opening and purchase something. Remember, people also bring their friends, who may become future clients. You can also send the invitation by e-mail to keep the expense down. From time to time (every two years), send a note or e-mail asking for a reply from the people on your list who want to continue receiving your free mailing. If people don't answer, drop them from the list.

WHEN SOMEONE SAYS NO

Remember, when selling it often requires a few "no's" before you will receive a "yes." Don't think that because you hear a no, it means never. You may have to contact a person a number of times before he or she will become interested. As an artist's career grows, people will become more interested. People know that as an artist gets better known, the artwork becomes more expensive. When people see that the artist is determined and her career is moving ahead, they will be more inclined to buy before the art becomes too expensive.

A simple way to strategize your success in selling art is to divide your activities into three logical steps. I call them "the three P's."

PICTURE IT

You must picture your greatest success and how it will look. Do whatever you can to see that picture. Close your eyes and imagine. Create a collage of cuttings from magazines that show your success as you want it to be. If you are an artist, you may want to draw or paint the success picture you wish to see. To the degree that you are able to picture yourself being the person you want to be, having the experience of success you want to have, and doing what you want to do with your life, that is the degree to which you will find yourself living your picture.

Next, picture your activities on a day-to-day basis. For example, if you have a meeting with a potential buyer, picture yourself having a good rapport with that person. Finally, picture yourself writing up the order.

Do this for every activity you think important and worthwhile. I practice this, and I can tell you that it works. You will be amazed when you learn the power of the picture in your mind. It is one of the most important exercises you can do. It is free and only takes a few moments.

PLAN IT

The next P is to plan your action. Organize yourself so that you do first things first. Every significant accomplishment has to start with a plan. Call it the blueprint for success. Plan your learning, your practice, your prospecting for clients, your selling strategies. If you are an artist, you need to plan what you will be selling and for how much. Look at how much you will need to sell every year to support yourself without working at another job. Plan how much time you will need to devote to that activity. Plan how you will create the work, how many pieces, what size they will be, how much your materials will cost, etc. Write down your plan and then go to the last P.

PROMOTE IT

The third P stands for promote. You will need to promote your mental picture and plan. You may need to get others involved to help you promote this vision. If your vision is generous and noble, you will find it easy to enroll others in your project.

THE THREE P'S

The pictures in your mind will create the reality you find.

Enthusiasm is the element of success in everything. It is the light that leads and the strength that lifts people on and up in the great struggles of scientific pursuits and of professional labor. It robs endurance of difficulty and makes pleasure of duty.
Bishop Doane

OVERCOMING ROADBLOCKS

To be a success at anything, one must be very well organized.
Charlie Chaplain

EXERCISE 1

Write down all the reasons why you don't or can't sell art the way you would like to. Don't look ahead at the text. Do this exercise first. See how many reasons you can come up with on your own. You will surprise yourself. There are probably a lot more factors holding you back than you think.

For example: "I'm a procrastinator."

The following list was put together by students in one of my "Art of Selling Art" seminars. It is a pretty good list but far from being all-inclusive. You will probably come up with some reasons why you don't sell art the way you would like that are not on this list. You may, however, find some reasons on the following list that should be on your list too. If so, add them now.

- ▸ I'm a procrastinator.

- ▸ I'm afraid I will be rejected.

- ▸ When it comes to selling, I haven't had any training.

- ▸ I don't know what to say.

- ▸ I don't know how to approach a potential client.

- I'm not confident in my presentation skills.

- I can't talk people into it.

- My goals aren't clear enough.

- I need some negotiation skills.

- I don't know how to close.

- I don't follow up.

- I don't know how to prospect.

- I need some telephone techniques.

- I don't know how to take control.

- I'm not assertive enough.

- I have a poor self-image.

- I need more confidence.

- I need to organize a sales approach.

- I'm in a period of low motivation.

- I'm too tired to work at it.

- I don't have time.

- I haven't made the commitment.

- I'm afraid to ask for a fair price.

- I am afraid I will fail.

- Artists shouldn't be salespeople.

- I am embarrassed to promote myself and my work.

- I don't want people to think I am pushy or annoying.

- I can't brag about myself or my work.

- People don't appear interested.

- I hate selling.

This exercise will empower you to succeed.

There is no such thing as a
good excuse.
Dero Ames Saunders

EXERCISE 11

It is very important that we become aware of our so-called shortcomings because
then we can do something about them. As an exercise in confidence-building,
rewrite your list, making each of the preceding statements into a positive statement
of strength. Don't worry that you don't believe it to be true at this moment. You
will see when you do the exercise how easy it is to change your mindset. At the end
of this writing exercise, you will feel that you can overcome your roadblocks. You
will know that what is really holding you back is your attitude. A change of attitude
is necessary and will empower you to succeed.

For example: "I never procrastinate."

The following list is the preceding 30 statements rewritten as statements of
strength. It was put together by students from my "Art of Selling Art" seminars.
This will help give you an idea of what I want you to do with your own list. First do
the above exercise, and then read over the following list.

- ▸ I never procrastinate.

- ▸ I am never afraid that I will be turned down or rejected.

- ▸ When it comes to selling, I'm great!

- ▸ I know what to say.

- ▸ I know how to approach a potential client.

- ▸ I'm always confident when making presentations.

- ▸ I know what questions to ask.

- My goals are clear, well-defined, and written down.

- I'm a skilled negotiator.

- I always know how to close.

- I always follow up.

- I know how to prospect effectively.

- I know how to use the telephone to conduct my business.

- I take control in any selling situation.

- I can be assertive when it is necessary.

- I have a strong and positive self-image.

- I have plenty of confidence.

- I have an organized sales approach.

- I'm highly motivated.

- I put my enthusiasm and energy into selling. I love it!

- I always find the time to sell because I know it is important.

- I have made the commitment to sell art.

- I always know my price and am not afraid to ask for it.

- I never allow fear of failure to stop me.

- I am an honorable and creative salesperson.

- I am proud to promote myself and my work.

- I am engaging and interesting.

- I am comfortable talking about myself and my work.

- I can tell when people are interested, even when they try not to show it.

- I love to sell art.

THE PAYOFFS

YOUR LIST OF PAYOFFS

Your personal reasons motivate your actions. Make a list below of all the reasons you want to sell art. Ask yourself the question, "Why do I want to sell art?" The more reasons you come up with, the better. Keep adding to your list as you continue your sales endeavors.

He who wishes to be rich in a day will be hanged in a year.
Leonardo da Vinci

SOME PAYOFFS

‣ Money

‣ Sharing

‣ Increased exposure

‣ To inspire excellence

‣ Personal satisfaction

‣ House improvements you've been wanting to make

‣ To feel validated

‣ Incentive to create more art

‣ To influence the world

‣ To add creative value to people's lives

‣ To promote a cause

‣ To support studio or gallery rent

‣ To increase public awareness

‣ Travel

‣ To inspire creative expression

‣ To increase the value of the artwork

‣ To raise self-esteem

‣ To be able to do what you love

‣ To add beauty to a working or living space

‣ Retirement savings

BUSINESS CARDS

My favorite card comes with a representative image of my artwork on one side in full color and contact information on the other side.

It is essential to have a good-looking business card. I have seen many creative ways to make distinctive business cards. If you are a gallery owner, it is important that each of your sales representatives has a business card from the gallery with her name on it.

A distinctive and elegant card will make a statement about the art you sell whether you are an artist, a representative or a gallery. It should state both verbally and visually the kind of art you offer. Whether or not your cards are expensive, they must look tasteful. There are wholesale printers that do high-quality four-color printing at very reasonable prices.

It's best to keep your card to the standard business card size of two by three-and-a-half inches. Create a folded card if you would like to include more information.

I once used a card that was two by seven inches for my business card. It had a panoramic painting from my sketch book displayed horizontally on one side and my contact information on the other side. It could be used as a bookmark, or it could be folded to the size of a standard business card, two by three-and-a-half inches.

Some printers for business cards:
www.elite4print.com
www.ultradotmedia.com
www.modernpostcard.com

You can print business cards directly from your computer to your office printer. This will allow you to vary your images and to print them as you need them. Pre-perforated papers can be found at any office supply store, or you can use card stock and cut it with a paper cutter. Paper that is glossy on one side is best. Print the image of your artwork on the glossy side and your contact information on the other side.

A business card should, at minimum, have your full name, address, phone, fax, e-mail and web site. Under your name or the name of the gallery, include a short description of your style of art: Contemporary Art, Sculpture, Impressionist, Modern Art, Original Paintings, Original Prints, Fine Art Prints, Watercolors, Oils, Photography, Contemporary Painting and Sculpture, Drawings, Landscapes, Portraits, Still Lifes. The more descriptive, the better.

FONTS COMMUNICATE VOLUMES

It is important that you carefully select a distinctive font for your card, one that is easy to read in small typeface. If you have the money to hire a graphic designer, she can advise you on font styles. If you are selling fine art, I think that a serif type is best. If your work is more abstract or contemporary, a sans-serif font may be more appropriate.

Always have your card ready to give to a person who offers you a business card. I make a point to jot down on the back of the card where and when I received it, as well as something else to help me remember the person. If she is a potential new client, keep the card in a special place. Enter her name on your mailing list for upcoming shows.

PRICING WORK

When I teach "The Art of Selling Art," I am always asked how one should price one's work. When I ask my workshop students what their prices are, I find that many of the students haven't considered what their prices should be. If they have considered their price range, I generally find the prices are too low. Some emerging artists price their work as low as the cost of the frame. There is an art to pricing, and it must be practiced thoughtfully.

DO YOUR HOMEWORK

Go to art galleries and look for work that would be in the same category as yours. Compare your work to artists who are at about the same place in their career, are working in the same medium and size, and have a similar skill level. Take note of the prices, remembering that an artist generally receives 50% of that price. If a work is sold for $1000, the artist generally will receive $500.

The gallery that sells my work will also give a 10% discount from the total retail price to clients who have purchased from the gallery before or are buying more than one work of art. In that case, the $1000 painting will be sold for $900. The gallery will take $450 and the artist will get $450. If the gallery wants to discount a price further to, say, 20%, then this added 10% discount is taken from the gallery's profits and not the artist's.

It is important that artists sell their work for the same price as the gallery that shows their work. If the artist sells work out of her studio for a lot less than the gallery, then there is a good chance the gallery will drop that artist; word will get around that a client can buy work for a lot less if he goes to the artist's studio. If you are an artist, it is important to have a written agreement about the commissions and discounts a gallery can take before you agree to let them sell your work.

'Read more about pricing in *Art Marketing 101, Third Edition*. www.artmarketing.com

CHAPTER SUMMARY

❏ You must have a body of work (12-20 completed pieces) unified in theme, size and media.

❏ Your work must be unique to you, not a take-off on another artist.

❏ Show only your best work.

❏ Create your work with selling in mind.

❏ Acknowledge your self-worth as an artist.

❏ Creating the right attitude is necessary and will make all the difference.

❏ It is your attitude much more than your aptitude that will determine your success.

❏ It doesn't cost anything to change your attitude.

❏ Create a business card you will be proud of.

❏ Give the card out to 10 new acquaintances this week.

❏ Reconsider your artwork's prices.

Chapter 2
Why People Buy Art

Motivations

An ideal product

Our only limitations are those which we set up in our minds or permit others to establish for us. Elizabeth Arden

MOTIVATIONS

Understanding why a person wants to buy art is an important part of the sales process. People buy art because it brings them pleasure, happiness, joy, inspiration, satisfaction, prestige, etc. If you want to sell art, find out what brings these feelings to your clients and then help them own your artwork. They will be grateful.

It is *not* important what you like, but what your client likes. Put yourself mentally and emotionally into the client's space; try to get inside her wants and desires. Envision the rooms in her house or office space where the art will be hung or displayed. Go with what she wants, what she expresses liking.

Most people buy artwork because they like it.

- They connect to a work of art with their emotions.

- They like the feeling they get when they look at it.

- The art speaks to them in a personal way.

- They may also have respect and admiration for the artist and the labor that went into creating the work.

- They may personally know and like the artist.

- They have great appreciation for the skill of the artist.

- They see that what they are buying is truly unique.

- They want a place (home, office, business environment) to feel more comfortable, elegant or special.

If you are convinced, you will be convincing.

Clients will, at times, ask you for your opinion about a work that they are admiring. Advise them according to your good and honest judgment. If you are convinced that the piece they are considering is right for them, advise them to buy it.

COLLECTING ART

Many people derive great joy from collecting art. They like finding treasures while they are traveling in exotic places. They enjoy displaying these finds in their surroundings. Often when I visit people, I am given a tour of their art collection. The tour always includes the name of the artist for each piece and where it was purchased. People also receive satisfaction from donating art from their collections to the fine museums of the world.

Some people think that buying art is only for the wealthy. It is true that when some people reach a certain financial status, they think that they should begin buying some original art. One client said to me, "I don't know anything about buying art." I said, "Let's have lunch and I will educate you." You can help people make wise choices while purchasing art. Always be completely honest with them, and they will be grateful to you and refer their friends to you.

ART IS FOR EVERYONE

People buy art by well-known or emerging artists because they want the pleasure of owning something that they really love, to beautify their homes or add prestige to their office. People buy art to enjoy it, to be inspired, and to feel good.

People spend their money for two basic reasons: to solve a problem and to make them feel good. Art is purchased for the same two reasons. People buy art for the same reasons they buy gourmet food, luxury cars, beautiful clothes, and expensive homes. Art is a solution to a problem—it is something to put on the wall or display in the hall. Art also makes us feel good—it is a decorative element in a home, office, school, church, hotel, or government building.

But art is so much more. Generally, people buy art for the second reason—good feelings. Art is a feel-good commodity. Art can also enrich a person's life by adding spiritual nourishment and inspiration. The value of an image can be far greater than the money spent. Certain images are more valuable than gold to people to transform consciousness, create satisfaction and bring happiness.

Art can also be a reminder of life's values. Art reminds people of the things in life that are more important than money: family, children, relationships, faith, values, passions or interests. Art enriches people's lives like nothing else. Art can delight the heart and mind. Art can remind people daily of their true value.

A SOLUTION TO A PROBLEM

Problem: One has to eat to stay alive.

Solution: One goes to the grocery store to buy food.

People buy cars because they need a fast and easy method of transportation, clothes to protect them from the elements, houses as shelter, doctors because they need medical attention, lawyers because they need legal assistance, architects to design buildings, tailors to alter clothes, and a cleaning service to clean offices or homes. All these services are made to resolve a problem.

People buy art because they need something on the wall. They want the room to feel more welcoming, warmer, friendlier and more lived-in. They buy sculptures to decorate their entry spaces, gardens and pools. People want to transform spaces with the addition of artworks.

You can tell a person's interest in and knowledge of art by what he displays on the walls. Many people are content to put a not-so-expensive frame on a poster or an offset print of a work by a famous artist. Others would not have anything on their walls but original artworks—one-of-a-kind pieces. This is also true of three-dimensional works—sculptures and statuary. Some people will display rip-off sculptural reproductions of works by famous artists. Others will only display original sculptures. I am often amazed to see inexpensive reproductions with cheap

Art is almost always obtained because the buyer feels some kind of personal connection.

31

When people buy art, they choose that which is a reflection of their own personality.

frames on the walls of professionals who could easily afford to own original works. Sometimes it may be appropriate to offer suggestions to a potential buyer who is not aware of the great difference between owning an original and an inexpensive reproduction. Remind them that what they display is a reflection of who they are— a reflection of their values.

TO FEEL GOOD

Another reason people spend their money is to get a good feeling. They go to the grocery store to buy food that tastes good to them—food that they enjoy. They buy gourmet food or organic food, even though it costs more, because they are having guests for dinner and want to serve them the best. They want to share their good taste and prosperity with their friends. This gives them good feelings—feelings of generosity, satisfaction, happiness. They buy luxury cars because the looks and the extra functions of these cars make them feel important and successful. They also like to drive a well-built car because they expect to have trouble-free transportation. People buy beautifully-made, expensive clothes to be well-dressed. They have their clothes tailored for a perfect fit to look their best and present themselves with elegant dignity in the social world. They can afford to dress well, so why not? People want to feel good about themselves, and beautiful clothes help them do that. People pay architects to design large, elegant homes for the same reasons. They want to feel good living in comfort and style and be able to entertain large groups of friends. They live in a country estate or an expensive neighborhood. It feels good to live like a king or queen. People hire plastic surgeons to look younger and feel better about themselves.

You can see how we often buy things for these two reasons: They provide a solution to a problem and create a good feeling.

BUYING ART FOR INVESTMENT

People sometimes buy art for investment purposes. I do not recommend selling art as an investment. It is always great to hear that something you purchased 10 years ago is now worth 10 times what you paid for it. But who wants to live with something that she does not like, just because it might go up in value?

A friend of mine began buying art when he was very young and had little money. He would pick up original drawings, paintings and prints at very low prices. In a few years, his apartment walls were covered with original works by many different artists. I'm sure that today some of these works are worth 10 to 100 times what he paid for them. But I'm also sure he would not part with his collection for the money. Most art is not bought for investment. Most people who buy art for investment spend a considerable sum of money on a piece because it has been created by an artist who is already well known.

It is illegal in the state of Hawaii to sell art for investment purposes.

AN IDEAL PRODUCT

Many people think that art is hard to sell; they believe that of all the products on the market, it is one of the most difficult to move. If you were to look for an ideal product to sell, what would it be? What advantages would it have? What qualities?

EXERCISE I

Look at the list below and check all the qualities that you think apply to art. This will help you realize that art is an almost ideal product. It will help you appreciate what you are doing when you sell art.

❑ everyone wants/needs

❑ will last

❑ won't break

❑ improves with time

❑ delights the heart/mind

❑ offers joy and peace

❑ makes life easier

❑ will inspire excellence

❑ can sell for a lot more than the cost to produce

❑ is collectable

❑ can generate future income

❑ someone other than the artist can sell

❑ other people will respect you for owning

❑ feeds the soul—spiritual nourishment

❑ causes a person to crave more

❑ all cultures value

❑ value is higher than price

❑ can't live without

❑ lifts a person's mood

❑ enriches people's lives

❑ you can see before you buy

❑ cannot be duplicated

❑ will inspire creativity

❑ will lead to more sales

❑ is more valuable than gold

Owning art is prestigious.

EXERCISE II

Just for fun, go through the list again and check all the qualities you think would apply to selling a BMW automobile. You probably will find that art is a much more desirable product to sell.

_____ _____

_____ _____

_____ _____

_____ _____

_____ _____

EXERCISE III

Now go through the list again. If you can think of more advantages, add them to the list. What are the qualities of the art that you are selling? List them here. Keep these in mind when working with a client.

_____ _____

_____ _____

_____ _____

_____ _____

_____ _____

CHAPTER SUMMARY

❑ People spend their money for two basic reasons: to solve a problem or to create a good feeling.

❑ Most people buy art because it makes them feel good.

❑ Some people buy art to reflect their success and social status.

Chapter 3
Client Rapport

Attracting clients

Keeping clients

ABC formula

The handshake

The hidden dimension: distance

Tone of voice

Dress for success

Body signals

Rapt attention is the highest form of flattery.
Anonymous

ATTRACTING CLIENTS

A major part of success in life lies in the ability to put first things first. Indeed, the reason most major goals are not achieved is that we spend our time doing second things first.

Robert J McKain

As a salesperson, have your objective be not only to make sales but also to meet and keep clients. Remember, your clients are for a lifetime. If you have this attitude and treat them thus, it will become true. Each individual you meet is important and deserving of your highest regard. Treat everyone with dignity.

TELLING IS NOT SELLING

One of the most effective ways to complete a sale is to engage in a dialogue with the potential client in which you ask questions that will lead to a buying decision. Salespersons not trained in selling art usually try to tell their clients about the works they represent. My experience has taught me that clients might politely listen for a minute or so, but as the representative continues to talk, they become less and less interested. By telling, you will end up losing their attention and a sale.

People don't like to be told. They would rather tell you! The way to get your clients really interested in owning what you have to sell them—art—is to ask them questions so that they can tell you their thoughts. The more they tell you, the more interested they will become.

Early one morning, when my son Michael was five years old, I discovered him waiting for me with his paintings displayed all over the dining room table. As I passed the table on my way to the kitchen to make breakfast, Michael stopped me and said, "Dad, I am selling these paintings. Which ones would you like?"

Well, not wanting to discourage my son, I stopped to admire his paintings. I selected two.

"I'll take this one and this one," I said, picking up the two paintings.

This is where he needed some training.

"How much will you give me for them?" he asked.

Always know your prices before you engage a client in a sales presentation.

Well, I thought, I'll take advantage of youth and inexperience. So I said to him, "How about 50 cents?"

"Only 50 cents!" he replied.

So then, feeling a little guilty, I said, "Then how about a dollar?"

Being only five years old, Michael thought that a dollar was considerably more than 50 cents and accepted my offer. So right there on the spot, I paid Michael the dollar and took possession of his artwork. With care and respect, I laid his artwork on my work table and proceeded to the kitchen to prepare breakfast. I thought we were finished. A few minutes later, Michael came into the kitchen holding a small drawing in his hand. My little son came up to me and said, "Daddy, this is for you." And he handed me his small drawing.

So, what did Michael do? He added something to the sale—something that I did not anticipate. He gave me more than I expected!

Which is more important: to make a single sale or to create loyal clients and collectors who will buy from you again and again? If you want to be successful selling art, give clients more than they expect to get. Gone are the days when you make a sale and the next day forget whom you sold to.

Get the idea that you are in the business of creating a base of clients who will buy from you again and again over many years. Your best clients will become good friends and loyal collectors. Your best clients will also become your best publicity agents for finding new clients to increase your sales.

My son Michael teaches us one more lesson here. When Michael asked me to look at his display of paintings, he asked, "Which ones would you like?"

Even at five years old, he knew that he could probably sell me more than one just as easily as one. And he was right: I bought two! If he had said one, I would have selected one. Think volume sales rather than single sales. Think packages rather than one-of-a-kind.

Michael was entrepreneurial. He didn't have a gallery or a professional sales location. He didn't have a business card or a car. He used the dining room table. He was resourceful. Of course he had a willing client, and he knew that. You, too, will have willing clients. Your parents and relatives can be very helpful. (My mom had a small antique shop. I used to wholesale my work to her, and she would resell it in her shop.) We must be open-minded and flexible. Learn to sell whenever and wherever you can—a client's home or office, home shows, sidewalk fairs, the local bank, restaurant, coffee shop, wherever the art happens to be. We need to take the art to our relatives and friends, just as Michael took his paintings to the dining room table and his dad.

It is wonderful if you have an elegant gallery space, but it is not necessary. A modest showroom or even a space that is rented for a weekend can inspire clients to buy. When they buy art in a low-rent showroom, they are not paying for the rental space. People always want to buy for less, as I did with Michael.

GIVING MORE THAN IS EXPECTED

When you sell something, make it a practice to give your clients something more than they expect. It could be a poster featuring the artist, a beautiful, large postcard featuring one of the artist's works, or an invitation to a private showing with the artist. If you are an artist, the task is easy. You have all sorts of things around your studio that you could make into a thank-you gift for your clients. It could be a commemorative poster from a past show, a print, a small sketch, a book that features your works—something that your clients will appreciate having.

KEEPING CLIENTS

To be successful in the business of selling art, think of ways to develop a loyal clientele—collectors who will buy from you again and again. One way to do that is to give your clients more than they expect.

ABC FORMULA

We can use a three-part formula to help us strengthen our client relationships. The stronger the rapport you have with a person, the more likely it is that he or she will want to do business with you. I call this formula the **ABC**'s of human relationships.

AFFECTION

A stands for affection. It means that you honestly care for another person. Affection is the genuine feeling of happiness to be with another person. If you find that this is difficult with some people, cultivate the attitude that there is always something you can pick out about another person that you can like. When people feel that you like them, they will likely return this affection. When people like you, they may be more open to your ideas. Always be polite to others. Make them feel important. If you do, you will have many good clients (and friends).

BEING IN AGREEMENT

B stands for being in agreement. The more agreement you have with a person, the more he or she will like you.

▶ The better you communicate, the more likely you will be to do business with the person. Ultimately, you want to agree that the sale is a good idea.

▶ Never, ever disagree or argue with a client. The client is always right.

▶ Use such phrases as, "That's right," "Good point," or "I see."

Client:	"Wow, that is really expensive!"
Salesperson:	"That's right! And it's worth it."

COMMUNICATION

C stands for communication. This means the imparting or interchange of thoughts, opinions, or information between two or more people. With communication and the exchange of information, anything is possible. Pausing, listening, questioning, and telling a person you understand what has been said will promote good communication.

When we are selling art, the degree of affection, level of agreement and quality of communication will either increase or decrease depending on what we say and ask and how we think, feel, and act in the presence of another person. These three conditions work together in harmony so that if one increases, they all increase. If one decreases, they all decrease. If you find that you are not in agreement, then you need to increase affection and improve communication. If communication is off, find agreement and increase affection.

In most sales situations, these ABC conditions are high when a sale is being made. After the sale is made, the level is even higher. Think of the process of selling art as both beneficial to the client and rewarding to you, with the bonus of cultivating some good friends and clients.

Always return phone calls promptly. Answer e-mail daily. Call before an appointment to verify the time.

THE HANDSHAKE

Each of the three ABC's is connected, like the three sides of a triangle, and each needs to be kept strong.

Both men and women should have a good, firm handshake. Always begin and end your meeting with a new client (and all follow-up meetings) with a firm and friendly handshake. This is usually the first gesture between two people, and if it is not a strong beginning, your meeting will be off right from the start. When you meet art gallery representatives, also begin and end your meetings with a handshake. You often can tell how enthusiastic people are by the way they relate to you through their handshake.

▸ A handshake should be firm but not hard.

▸ It should be given with a warm smile.

▸ It should not be an uncomfortable squeeze.

▸ It should be short and to the point. Do not hold on. People who hold on to another person's hand may make that person feel uncomfortable. Sometimes people will do this as a way of holding your attention. If a client does this to you, it is best to grin and bear it. But don't do this to a client or gallery representative.

▸ A handshake should not communicate in any way that one person is superior to the other.

▸ Do not squeeze the other's fingers.

▸ Get a good grip of the entire hand, and if you don't get a good grip, do it over.

THE "WET FISH"

This is what we used to call a limp, soft handshake. When someone does this to you, you get the impression that the person is not really interested in having a strong connection, does not want to make a good impression or is indifferent. Some women do this because they think it is more gentle and feminine. It is not a good idea to do this. The "wet fish" communicates weakness of character.

THE POWER SQUEEZE

Some men like to show off their physical strength when shaking the hand of another man. It communicates superiority and the desire to dominate. It does not communicate sincerity and warmth, but just the opposite; it communicates cold, hard domination. If you have a strong grip, be careful how you use it.

THE FINGER CRUSHER

This happens when someone squeezes the fingers of another. It is not a handclasp but a finger crunch. The person on the receiving end feels put off and a little cheated. Sometimes it can happen when one clasps the other's hand too soon. (Try

to be sure that the flesh between the thumbs and the first fingers is touching before the hands close.) When I get one of these handshakes, I say quickly, "Let's do that again." At the same time I gently take hold of the other person's wrist, release my hand and push it into the other person's hand quickly before he or she knows what's happening. That way we get a good handshake and start our meeting on a positive note.

THE DOMINANT/SUBORDINATE HANDSHAKE

This happens when one of the parties has his hand on top of the other person's. Usually he comes in for the handshake with a circular motion from above. His hand comes down onto the other person's. The dominant person has his hand on top of the subordinate person's. It is done quickly, and the nonverbal message is that the person with the hand on top is dominating. If someone does this to you, simply straighten out your hand so that the dominant hand will be vertical alongside your own.

THE FRIENDLY, WARM HANDSHAKE

The best handshake is the friendly, warm handshake, in which both parties clasp hands in a firm way. Both hands are vertical with their fingers pointing to the other person. The two clasps are equally firm—not squeezing, but firm. The shake is brief, friendly, and the two parties look each other in the eye and say, "How do you do?" or, "I'm very glad to meet you." Usually names are exchanged at the same time. It is the proper way today between two men, two women, or a man and a woman.

There are many truths of which the full meaning cannot be realized until personal experience has brought it home.

So much is communicated nonverbally with a handshake.

THE HIDDEN DIMENSION: DISTANCE

The quality of your relationships will determine your success.

Physical distance plays an important role in relationships. It is always important to find and feel the right psychological and physical distance for the other person.

If one gets too close physically to another person, it can have a negative effect: The person may feel uncomfortable. Conversely, someone else may feel that the distance between you is too great to have meaningful communication.

Let the other person determine the distance. Remain at that distance for the duration of your conversation. Sometimes, you might feel a little uncomfortable because the distance is too small or too large for your own comfort. Learn to accommodate your client.

When working in a gallery or studio space with clients, it is wise to be aware of spatial relationships between yourself and your clients. Americans have certain spatial envelopes that are comfortable in different situations. What I instruct my students to do is to allow the buyer to establish the distance that is comfortable. Then you, as the salesperson, stand firmly in that position, even if it may feel awkward.

When two or more people are sharing the experience of viewing a painting or sculpture, the attention is on the art piece. In this situation, the physical distance between people can be quite close, and, at the same time, comfortable. However, if you are facing a person and having a conversation, then the distance has to be a comfortable social distance. This distance can vary greatly among different cultures. Unless you are able to respect a person's cultural spatial comfort, you may find it difficult to establish and keep rapport.

Distance is an important consideration. Edward T Hall found it so important that he wrote a book on the subject, titled *The Hidden Dimension,* first published in 1966. In his book, he outlined four principal categories of spatial relationships: intimate, personal, social, and public. His research showed that these distances are fairly constant in our American culture but vary considerably among foreign cultures.

The following chart shows Mr Hall's four categories of measurements:

INTIMATE DISTANCE
Close phase: touching to 6 inches Far phase: 6 - 18 inches

PERSONAL DISTANCE
Close phase: 1.5 - 2.5 feet Far phase: 2.5 - 4 feet

SOCIAL DISTANCE
Close phase: 4 - 7 feet Far phase: 7 - 12 feet

PUBLIC DISTANCE
Close phase: 12 - 25 feet Far phase: 25 plus feet

The best distance for an American to maintain for a discussion about art sales would be the Social Distance—Close phase. Of course, the discussion might begin at the Social Distance—Far phase. At the Social Distance, the voice level is normal and both parties feel "safe."

EXERCISE I

In order to become more aware, stand with a friend at different distances. Find the most comfortable distance to have a conversation and measure it with a tape measure. See how far away you can get without feeling awkward. Now try to stand closer. See how close you can get without feeling uncomfortable. Note that the distance is the same for both of you unless you are from different countries.

EXERCISE II

Now stand together looking at an artwork. See how close you can stand side by side and feel comfortable. Measure the distance. You will see that there is quite a difference between this and the above distance.

Be mindful of spatial relationships.

Man's feeling about being properly oriented in space runs deep. Such knowledge is ultimately linked to survival and sanity. To be disoriented in space is to be psychotic.
Edward T Hall

TONE OF VOICE

Controlling your voice is very important. Learn to use it to your advantage.

Your tone of voice has a profound influence on the mood and rapport that you will have with your clients. Ask your good friends to comment on your tone of voice. Do you speak too loudly or too softly? Does your voice sound harsh? Do you speak too fast or too slow?

Learn to be aware of the tone of voice you usually use. Find out if it has the effect of making people feel relaxed. One way to become more aware of this is to set up a tape recorder and record a conversation with a friend. Play it back, listening to your voice. What do you hear?

SPEED OF SPEAKING

When you are working with a client, match the tone of voice and the speed of speech that your client is using. This will help your client feel at ease with you. When you are speaking to a client on the telephone, do the same. Remember, the more rapport you have with a person, the more likely the person will buy from you. Match his speed and tone of voice. Practice this when you speak on the phone with anyone, and soon you will be in the habit of matching tone and speed for all your business conversations.

Potential clients form their impression of you in the first instant after meeting you. You will never get a second chance to make this first impression. How you appear will have a strong effect on whether they want to do business with you. How they look is not important. What matters is how you look. Do you look like a person who will be selling a work of art? Do you look like you know what you are doing?

People will not tell you if they don't approve of or appreciate the way you look. You must be self-aware and make yourself look the part that you have chosen to play. If you want to be financially successful, dress like you already are successful. Dressing well can help you feel good inside. You will have more confidence because you know you look great.

THE ARTIST

Wearing your painting or sculpting attire may not be a good way to present yourself to a potential buyer. Many people have difficulty relating to another person who is dressed radically differently from themselves. Remember that your goal is to gain rapport. Dress in a way that will help your client feel comfortable. Look like a professional. The way you dress can either put another person off or make him feel good to be with you. Forget your own comfort and dress the part. Make sure that your hands and fingernails are clean. Most people will feel more comfortable shaking a clean hand.

MEN

Men should wear a suit or sport coat. On the East Coast, a necktie is a must. On the West Coast, dress tends to be a little more casual, and an open-necked shirt is sometimes acceptable. In Hawaii, the dress is even more casual and men can sometimes look appropriately attired in a beautiful aloha shirt. Men should always wear neatly pressed long trousers with a belt—never shorts or jeans in a business setting. Your hair, mustache or beard should be neat and trimmed. Always wear socks and shined shoes. In tropical climates, good-looking sandals may be worn with socks.

WOMEN

Women should wear business attire. Scarves and other accessories can add flair and color. Women's hair should be well groomed and neat. Keep shoes clean and shined, and only wear sandals or open-toed shoes if they look professional on you.

DRESS FOR SUCCESS

A gallery show or reception can be an opportunity to put on a little flair. Use color and have some fun with style. Look good, feel confident, and you will meet and connect with people easily.

BODY SIGNALS

Experts say that 85% of what you communicate is not with words but with your tone of voice and your posture—the way you sit or stand, the way you move, what you do with your hands, and your facial expressions. Here are some suggestions that will help you gain rapport with the people you meet.

SMILE

A smile is a very powerful way to connect with people and assure them that they can talk with you freely. When you greet a person, smile a real smile that engages your eyes as you offer a firm handshake and say:

Salesperson: "Welcome to the gallery (the studio). I'm Rick."

People often make a judgment in the first 10 seconds of meeting someone as to whether or not they like the person. A true smile will help you give a good first impression.

EYE CONTACT

When you maintain good eye contact with your client, it shows respect and interest. Focus both your eyes on one of his. Look at him without staring. Both of you will then feel comfortable. Avoid looking at the person's forehead, lips, or mouth.

HANDS

Watch out for unconscious mannerisms. If you fidget, it is a sign that you are ill at ease. A good rule is to keep your hands away from your head, neck and face. Keep your hands at your sides if you are standing, or resting comfortably in your lap if you are sitting. Nervous hand movement will distract the person who is listening to you. If you use your hands along with your voice to communicate, that is fine, as long as the hand movement supports what you are saying. Practice in front of a mirror. Ask your friends to comment on your hand gestures.

- Clasped hands may signal that you are closed.

- A palm-to-palm gesture with one thumb over the other may communicate that you need reassurance. To be perceived as confident, honest and receptive, keep your hands relaxed, open and visible.

- Hands in a pocket may communicate that you have something to hide.

ARMS

Crossing your arms over your chest may signal that you are close-minded, defensive, self-protective, or not interested.

LEGS

Don't cross your legs when you sit. This posture may signal a barrier between you and the person to whom you are talking. It can also be a distraction. Even crossing your ankles can be a distraction. Do not shake your legs.

POSTURE

Practice good posture. Pull your head and shoulders back; stand tall and sit straight. Not only will it make you feel more confident, but you will be more relaxed because your breathing will improve. If you feel nervous, a change in your posture may calm you down.

FINGER GESTURES

Don't wiggle your fingers. Never point with your index finger while curling up the other three fingers. If you want to point, extend your index finger just a bit more than the rest of your fingers, keeping your hand open, or point with your whole hand.

RELATIONSHIP SELLING

The key to selling art in a gallery, studio or anywhere else is your ability to develop and maintain good relationships. That means that every human encounter, every opportunity that you have to meet people, talk with people, or be with people is an opportunity to develop a good relationship. That is why at the beginning of this book, I said that selling art is a process of establishing rapport with a qualified client.

I recently talked to a man who had been selling art for the past 30 years. He owns two art galleries in two different cities. I asked him what he considered the most important thing for success in the art business. Without missing a beat, he said, "Relationships."

Study people who are being interviewed by talk show hosts or giving speeches on television, and watch how their bodies communicate.

CHAPTER SUMMARY

❏ Think volume sales rather than single sales. Think packages rather than one-of-a-kind.

❏ Learn to sell whenever and wherever you can—wherever the art happens to be.

❏ When selling art, remain open-minded and resourceful.

❏ Orient your thinking to ways to develop a loyal clientele—collectors who will buy from you again and again. One way to do that is to give your clients more than they expect.

❏ People's emotions are a more powerful motivator to buy than their reason.

❏ Learn what questions to ask to involve your client emotionally.

❏ It is much easier to connect with your clients emotionally than to try to help them overcome their objections. When people really want to own a work, they will overcome their own objections.

❏ People need good reasons to help rationalize spending their money. Provide reasons.

❏ The ABC of human relationships will determine your degree of rapport. The more rapport you have with a client, the better your chances of making a sale.

❏ Always be polite to others and make them feel that they are important. If you do this, you will have many good clients as well as return clients.

❏ If you don't have a good handshake, practice until you get in the habit of giving a good, firm handshake.

❏ Begin and end all meetings with a good handshake.

❏ Use good eye contact with your clients, but don't stare them down.

❏ Let the buyer establish the distance that is comfortable. Then you, as the salesperson, stand firm in that position, even if it feels awkward.

❏ Remember that your tone of voice communicates volumes.

❏ Ask friends to comment on your tone of voice.

❏ Tape-record your voice during a real conversation.

❏ Match your speed of speaking and tone of voice to your client's, practicing on the phone and in everyday conversations.

❏ Stand and sit with good posture.

❏ Keep your arms, hands, and legs steady and where they belong.

❏ Smile, breath, relax, and stay present.

Chapter 4
Sales Skills

Four skill levels

The elevator to success is out of order. You'll have to use the stairs, one step at a time. Joe Girard

FOUR SKILL LEVELS

There are four stages to learning a new skill.

UNCONSCIOUSLY UNSKILLED

When you began reading this book, you may not have had much of an idea about what was involved in the selling of art. This is the beginning level. Think about learning to sell the same way you would think about learning to drive a car. I call it a skill you can learn. Remember when you didn't know anything about driving a car? I call this level "unconsciously unskilled."

CONSCIOUSLY UNSKILLED

The second level is when you have some idea about what you need to learn to master the skill (in this case, sales). Let's say you have read this book, but that is all. Reading alone will not help you much. You have to make a commitment to put the information you have read to use—to practice what is recommended. You can read the driving manual as much as you want, but until you get behind the wheel of a car and practice driving, you will not know how to drive.

CONSCIOUSLY SKILLED

The third level is being consciously skilled. This is the stage when you begin to practice selling art. At each stage of this part of the process, you have to think, think, think. What is next? Am I doing this right? What question should I ask now? Which question should I ask to close? When you learned to drive, you had to remember how to turn a corner, signal a turn, watch your speed, stop at stop signs. You knew if you did not remember these things, you would fail the driving test. You had to remain alert and conscious about everything you did. The same goes for sales at this level of skill.

UNCONSCIOUSLY SKILLED

When you become unconsciously skilled, you have graduated to the fourth and final level. At this stage, you have practiced so many times that what you say and do during a sale has become second nature. You will have developed your own methods of gentle selling, which incorporate suggestions in this book.

- You involve your clients in the works of art you are selling by asking them questions and listening to their answers.

- You know how to find out what they want.

- You know how to test and close your sales (Chapter 9).

- You routinely ask for referrals.

Expect to sell.

▸ You have a good vocabulary and never use negatively-loaded words.

▸ You build rapport with your clients so that they keep coming back to you.

You will learn all these methods in this book. They will become second nature, just as when you drive a car now, you can listen to the radio, carry on a conversation, and still automatically stop, signal, turn, watch your speed, and drive safely without giving it much thought.

The best way to get good at selling art is to practice selling art. When you have done it for a year or two, you will be at the fourth level.

CHAPTER SUMMARY

❑ There are four skill levels in selling art. You are unconsciously unskilled at the first level. You don't know what you don't know.

❑ The second level is when you become consciously unskilled. You know what you need to learn.

❑ The third level is becoming consciously skilled. You need to consciously think at each step of the process.

❑ The fourth level is becoming unconsciously skilled. You are very practiced, and you move through each step of the process with ease and confidence. Your skill is almost automatic—you can perform appropriately without much thought.

❑ The best way to get to the fourth level in selling art is to practice selling art!

Chapter 5

Word Power

14 power words

Negative words

Increasing your vocabulary

Describing colors

Describing artists

Art jargon

Everything depends upon execution; having just a vision is no solution.
Stephen Sondheim

14 POWER WORDS

Listed below are 14 power words to remember to use when you are selling art. Use them in conversations with clients as well as when writing promotional material for press releases or publicity announcements. These words attract curiosity, create interest, inspire imagination and motivate action.

BEST	DISCOVER	EASY
GUARANTEED	LOVE	MONEY
NEW	OWN	PROVEN
SAFE	SAVE	TRUST
VALUE	YOU	

Following are sample sentences using these 14 power words in a descriptive format.

BEST

You can be assured that you are acquiring the best.

In the field of modern impressionists, she is one of the best.

This is the best price for these that you will find anywhere.

DISCOVER

This artist's work has just been discovered.

Discover the power in this artist's paintings.

I want you to discover how easy it is to own this artist's work.

EASY

With these prices, it is easy to own the work.

The style is easy to like.

The artist's painting style is captivating and easy to understand.

GUARANTEED

These bronzes are guaranteed to last for thousands of years.

These prints are guaranteed to delight any discriminating collector.

These paintings are guaranteed to add _____ to your life.

LOVE

When you fall in love with a work, you just have to own it.

You will love this artist's new work.

I just love the wild colors in this painting.

MONEY

When you purchase a piece during this show, you will save money.

If you would like to save money, we can offer you a discount if you buy more than one print at a time.

NEW

We are featuring new work by _____.

These new paintings (sculptures, prints) are the subject of this special exhibition.

His recent work addresses a new theme in his painting.

OWN

When you see these new works, you will want to own them all.

Just think what it would be like to own an original _____.

PROVEN

His work has proven to be the most popular with our clients.

Our reputation for quality art and service has been proven by our 25 years in business as a highly regarded art gallery.

SAFE

When you buy from our gallery, you have the safety of knowing that we will live up to our fine reputation for care and trustworthiness.

You can be sure that we do not hold back on the framing; we need to insure the safety of the piece.

SAVE

By deciding today, you can save the cost of framing and shipping.

Our art consulting service can save you hours of shopping time.

When you purchase more than one piece, you can save money with valuable discounts.

TRUST

You can trust that we have a reputation to uphold and we operate our gallery with the highest integrity.

You can trust that this is an authentic original.

VALUE

These original prints are a great value because the artist is still relatively unknown.

You and your family will value this piece for many years to come.

The piece has exceptional value.

YOU

You will love the power and magnificence in this work.

You will want to own an original _____.

I knew that her work would appeal to you.

Now let's demonstrate how these words can be used in interrogative sentences. I've taken the preceding sentences and made them into questions. In the question format, these words are even more effective.

BEST

You would like to be assured that you are acquiring the best, wouldn't you?

Do you know that in the field of the modern impressionists, she is one of the best?

Do you know that this is the best price for these that you will find anywhere?

DISCOVER

Can you imagine that this artist's work has just been discovered?

Would you like to discover how easy it is to love and own this new artist's work?

EASY

With these prices, it is easy to own the work; don't you agree?

It is a style that is easy to like, isn't it?

Can you see how this artist's direct painting style is easy to understand and is still captivating?

GUARANTEED

Did you know that we guarantee that these bronzes will last for at least a thousand years?

Don't you agree that these prints are guaranteed to delight any discriminating collector?

Did you know that everything in the gallery is guaranteed to be authentic?

LOVE

When you fall in love with a work, you just have to own it; don't you agree?

Don't you love this artist's new work?

Don't you just love the wild colors in this painting?

MONEY

Do you know that when you purchase a piece during this show, you are going to save money?

Do you know that if you buy more than one of these prints at a time, you will save considerable money?

NEW

Would you like to see the new work we are featuring by _____?

Do you see how this recent work addresses a new theme?

OWN

When you see these new works, you want to own them all, don't you?

Can you imagine what it would be like to own an original _____?

PROVEN

I'm sure you are not surprised that his work has proven to be the most popular with our clients, are you?

Do you know that we are a highly regarded art gallery proven by 25 years in the art business?

SAFE

You know, don't you, that when you purchase art from our gallery, you have the safety of knowing that we will live up to our fine reputation for care and trustworthiness?

Can you see how using these 14 words in a question format will increase communication and agreement?

You can be sure we will frame the piece properly; we need to insure the safety of the piece, don't we?

SAVE

Would you like to save the cost of framing and shipping?

Would you like to learn how our art consulting service can save you hours of shopping time and money with valuable discounts?

TRUST

Can you trust that we have a reputation to uphold and that we operate our gallery with the highest integrity?

You know you can trust that this is an authentic original, don't you?

VALUE

Don't you agree that these original prints are a great value?

Can you imagine how you and your family will value this piece for many years to come?

Can you see the exceptional value here?

YOU

Don't you love the power and magnificence in this work?

Wouldn't you like to own an original _____?

Her work appeals to you, doesn't it?

When selling art, you should avoid certain words. These words are negatively charged and will, in many cases, cause a client to feel uneasy or uncomfortable—just the opposite of what you want. We want our clients to feel relaxed and at ease while they are making decisions to own art. Word choice and tone of voice will help your client feel at ease. Following are nine emotionally-loaded words to avoid, with some suggestions for substitutes.

BUY

acquire	collect	have	invest	obtain
own	take	add to your collection		

opportunity to own

CONTRACT

agreement paperwork

COST OR PRICE

available for	being offered at	goes for	monthly investment
ranges	total investment	valued at	worth

CUSTOMER

client	colleague	collector	friend	patron

DEAL

opportunity

DOWN PAYMENT OR DEPOSIT

initial investment put something down

PITCH

demonstration presentation

SELL OR SELLING

distribute	exhibit	letting it go	make available	market
offer	place	present	promote	provide
represent	show			

SIGN

approve	authorize	endorse	okay	complete the paperwork

NEGATIVE WORDS

"Own" has the connotation of gaining something. "Buy" has the connotation of losing something.

INCREASING YOUR VOCABULARY

When you are talking with clients in a gallery or at an opening, it is important to use a good vocabulary to describe the work of art and the artist. The more colorful the words you use, the more impressive your descriptions will be. Too often I hear people describe art by using only one or two words—"interesting" or "nice." Refrain from using either word. The word "interesting" doesn't communicate much more than, "I don't know what else to say." The word "nice" communicates, "I just want to say something positive."

When speaking about a specific work, find the right words to describe how you feel and what you see. When you need to write press releases, artist's statements, or reviews about artwork, it is helpful to have a strong art vocabulary. Use the following lists of words as a resource. Add to the list other words that you find appropriate. These words will help you create impressive statements about the art, the artist you represent, and the colors you see.

EXERCISE

Write a one-sentence description of the art you are selling using the lists on the next two pages. Use at least one word from the first, second, third and fourth columns. You will see how easy it is to come up with a strong, descriptive statement. Give it a try.

DESCRIPTIVE WORDS FOR ARTWORK

admired	aesthetic	alive	amusing
appealing	articulated	acerbic	attractive
available	awesome	basic	bitter
breakthrough	bright	brilliant	busy
calm	captivating	charming	classic
classy	clean	clever	creative
collectable	colorful	commanding	compelling
contemporary	contrasting	contoured	conversation piece
cool	cozy	current	dark
dazzling	delectable	delicate	delicious
delightful	depth	detail	dominating
dramatic	dreamlike	dynamic	dynamite
earthy	easy	electric	elegant
elite	energetic	enigmatic	ethereal
esthetic	evocative	explosive	exquisite
extraordinary	fascinating	fancy	fantasy
fiery	finely crafted	flavor	flowing
free	freedom	fresh	fun
glorious	glowing	gorgeous	graceful
great	handsome	harmonious	human
humane	humorous	iconographic	imaginative
important	influential	ingenious	innovative
inspiring	intelligent	intense	intricate
inventive	keen	latest	lifelike
light	limited edition	lucid	liquid
lovely	luminous	magical	magnetic
magnificent	masterful	masterpiece	melodious
metaphysical	moving	museum-quality	musical
new	naïve	natural	organic

Do what you love, love what
you do, and deliver more than
you promise.
Harvey Mackay

original	ornate	otherworldly	outstanding
painterly	passionate	perfect	playful
potent	powerful	precious	presence
primitive	quiet	rare	recent
respected	restful	revolutionary	rhythmic
rubbery	serene	sharp	shine
smart	soft	spicy	spiritual
splendid	spontaneous	striking	strong
stunning	sweet	tasteful	tempting
textured	tour de force	traditional	treasured
up-to-date	valuable	valued	vibrant
vigorous	vital	warm	weird
well-regarded	whimsical	witty	wonderful

DESCRIBING COLORS

It is important to have a good vocabulary to describe colors as it will

▸ Expand your own ability to see and appreciate color

▸ Make you more knowledgeable as a professional

▸ Give you a more accurate and distinctive vocabulary

▸ Help you discuss the subtleties of color

▸ Help you educate and expand your clients' knowledge of color.

Looking for just the right name for a color? The following list will give you some suggestions. Some of the colors listed are the names of colors on tubes of oil paint, acrylic paint and watercolor that will be familiar to artists. Add your own colors to this list.

EXERCISE

Write a descriptive statement about a real art piece that you represent, using the previous list and some of the colors from the following pages.

Artists can color the sky red because they know it's blue. Those of us who aren't artists must color things the way they are or people might think we're stupid.
Jules Feiffer

DESCRIPTIVE WORDS FOR COLORS

alabaster	alizarin crimson	almond	amber
amethyst	antique gold	apricot	aquamarine
auburn	aureolin	azure	basic black
beige	blond	blue	blue violet
blue-black	brilliant white	bronze	brown
buff	burgundy	burnt orange	burnt sienna
burnt umber	cadmium orange	cadmium red	canary yellow
caramel	cerise	cerulean blue	chartreuse
Chinese red	chocolate	cinnabar	coal black
cobalt blue	cobalt green	colorless	copper
coral	cream	crimson	cyan
deep red	deep . . . etc.	dioxazine purple	ebony
ecru	emerald	emerald green	flake white
flame red	flaxen	flesh	flesh tone
forest green	full spectrum	geranium	gold
goldenrod	grape	grass green	gray
ice blue	Indian red	indigo	iridescent gold
iridescent white	iridescent . . . etc.	ivory	ivory white
jade	jet black	lamp black	lavender
leaf green	lemon yellow	light yellow	lilac
lime	luminous gold	luminous green	luminous . . etc
magenta	mahogany	marigold	marine blue
mars black	mauve	midnight black	midnight blue
mint green	mistletoe	Naples yellow	navy
navy blue	neutral grey	off-white	olive
olive green	orchid	peach	peacock blue
pearl	pearl white	pewter	pink
plum	Prussian blue	Prussian green	pumpkin
pure white	radiant gold, etc.	raven black	raw sienna
raw umber	reddish . . . etc.	reddish violet	rose

ruby	russet	rust	salmon
sandy	sap green	sapphire	scarlet
scarlet lake	sepia	shocking pink	sienna
silver	sky blue	smoky gray	spring green
straw	sunset orange	tan	tangerine
taupe	tawny	terra verte	turquoise
turquoise blue	ultramarine	ultramarine blue	umber
Van Dyck brown	Venetian red	vermilion	violet
viridian	viridian green	white	
whiter-than-white	winter white	yellow ochre	zinc white

DESCRIBING ARTISTS

When you are talking to clients, or writing a biography, it is important to have a good vocabulary to describe yourself or the artist you represent. Artists can be colorful and fascinating characters. The more vivid the words you use, the more impressive your descriptions will be.

When you write about yourself or the artist you represent for a press release or a biographical statement, the list below will give you ideas to make your written statement more exciting to read.

EXERCISE

Write a sentence describing an artist, using at least three words from the following list. If it is about yourself, write the sentence in the third person.

Example: "Pablo Picasso, a robust, clever and dedicated artist while he was alive, produced a huge body of imaginative and masterful drawings, prints, paintings, and sculpture that has won the respect of collectors of modern art worldwide."

DESCRIPTIVE WORDS

able	accurate	adept	admired
adroit	alert	ambitious	amusing
appreciated	articulate	artistic	authoritative
aware	brave	bright	brilliant
bold	calm	capable	careful
celebrated	charming	clever	commanding
compassionate	competent	confident	conscious
consistent	contemporary	controlled	creative
current	decisive	dedicated	demanding
detail-oriented	devoted	dominant	dominating
emerging	energetic	enlightened	entertaining
enthusiastic	established	esteemed	experienced
expert	fine craftsman	foreign	fresh voice
friendly	gifted	great	hardworking
honest	honored	humane	humorous
imaginative	individualistic	influential	ingenious
inspired	integrity	intelligent	intellectual
inventive	keen	known	loved

magnetic personality major masterful modern

most imitated motivated mysterious new

national treasure outstanding passionate potent force

played a major role powerful practiced prolific

prominent quick-witted recent reliable

renowned resourceful respected revered

risk-taker robust scholarly seasoned

sharp simple skillful smart

sophisticated spontaneous straightforward successful

timely trained treasured truthful

up-to-date valued veteran vigorous

weird well-known well-regarded witty

won the respect of . . .wonderful worldly

We don't see things as they
are, we see them as we are.
Anais Nin

ART JARGON

Be careful about using art jargon.

Some art magazines are notorious for publishing articles filled with what I call "art jargon" or "art speak." When you read these articles, if you don't know the meaning of certain esoteric words, you can only guess what the author is talking about. Likewise, if you use specialized vocabulary with a client who is not familiar with the art world or its vocabulary, but who appreciates art and is interested in owning it, you will not build rapport. You may make your potential buyer feel stupid or uneducated, or even embarrassed to admit that she doesn't understand what you are saying. If your buyer feels stupid, she won't want to do business with you. Be careful not to use art jargon in artist's statements or reviews, either.

Here are some words and phrases I found in articles in one recent *Art in America* magazine. Read them over and see what they mean to you:

Tyro fashionistas

Constabulary

In the frenzy of its waning efficacy

Cosmopolitan paganism

Protean

Euphemism for the prim denial of the physical world

Designophiles

Tangible redoubts

Redacted and suppressed

The dearth of opportunities to accessorize their private dreams

Conflate

Anthropomorphic hologram

Occluded

Inherent constituents

The somatizing of social position

Postmodern depersonalization

Paucity

Abstract constructivist rigor and figuration

Intensified the somatic and psychological dislocations

Nudges the drama out of the realm of the existential and into the absurdist social critique

Partly poignant image

A penchant for hyperbolic fantasy

An anachronistic language

You may be able to guess what the author was trying to say, but my advice is to stay away from this kind of language when you are talking with clients. Keep it simple and straightforward.

CHAPTER SUMMARY

❑ Use the following words—best, discover, easy, guaranteed, love, money, new, own, proven, safe, save, trust, value, you—when you write about or discuss art with your clients.

❑ Use the above words when you write promotional or publicity materials.

❑ Remember that these powerful words attract curiosity, create interest, inspire imagination, and motivate action.

❑ The words you use will influence the degree of comfort your client experiences when making a buying decision. Here is a quick reference of substitute words. Make using these substitute words a habit.

- sell or selling = offer or offering

- buy = own

- cost or price = value

- contract = paperwork

- pitch = presentation

- customer = client

- deal = opportunity

- sign = endorse

- down payment or deposit = put something down

❑ Invent your own creative way of offering art. For example, you could say, "Would you like this piece to come live with you?"

❑ Communicate, whether orally or written, in a simple, easy-to-understand language.

Chapter 6
Phone Power

Using the phone

Making sales calls

Knowing is not enough; we must apply. Willing is not enough; we must do.
Johann von Goethe

USING THE PHONE

The telephone is an important tool in the selling process. I have sold art over the phone to people who have seen the art but have never met me. It hasn't happened often. Usually you will need to make face-to-face contact with your client before a sale takes place. Your comfort and skill on the phone can greatly enhance the effectiveness of your efforts to get appointments and close sales. Each time you talk on the phone, whether it is to a client or a friend, practice some of the following suggestions to develop good telephone skills.

A VOICE PICTURE

Remember that both the inflection and tone of your voice communicate. What we say with words is only part of the message. When we talk on the phone with a stranger, we get a visual picture of the person from her voice—a voice picture. If your voice sounds upbeat, strong, clear and confident, the person you are talking with will receive a good impression.

Be sure to speak distinctly. Don't talk too fast or slur your words. Phone connections, especially on cellular phones, can be unclear. You may hear your client perfectly, but the client may be having difficulty hearing you.

ANSWERING THE PHONE

When you answer the phone, say the name of your company and then give your first name or your first and last names.

> "Contemporary Art Gallery, this is Rick Smith."

If you are an artist answering the phone, you may want to say just your last name or your first name instead of, "Hello." I answer my phone by saying, "This is Robert," with an upbeat tone at the end. I have at times just said my last name. I don't say, "Hello." "Hello" doesn't sound businesslike.

Be sure to answer the phone distinctly. If you have employees, coach them on good phone techniques. My office assistant answers my phone with, "Robert Dvořák's studio, this is Laura." Have your employees read this section of the book, and then practice with them. So many times when I've called an office and the person gave his name, I couldn't understand what it was. I had to ask the person to repeat it. I always want to know at least the first name of the person I am talking to. I have learned that if the person on the phone knows that you care enough to identify him by name, that person will likely be more courteous and helpful.

When speaking on the phone, use the person's name during the conversation. This will help increase your rapport with the other speaker. Sound upbeat and sincere. Sound like you are glad to be having this conversation. Ask your friends how you sound on the phone. Ask them to give you an honest assessment. Then work to correct any poor habits you may have.

When you answer a business call, always acknowledge the caller's interest and use the caller's name.

Salesperson: "Thank you for calling about the large painting in the gallery show, Judy."

or

Salesperson: "I'm pleased you want to come for a studio visit, Bill. Would Tuesday afternoon at 3:00 work for you, or would Wednesday at 10:00am be better?"

▸ When possible, answer with a question that will lead to an appointment.

▸ When making an appointment, confirm all the details.

▸ Be sure to verify with a phone call the day of the appointment.

PHONE LOGS

Have a telephone log next to your phone. I use a three-ring binder that I keep open. It is filled with blank pages, and I make notes in it while I am talking on the phone and after the call is complete. It is a good idea to date each page; that way you can keep track of all your calls, and the information is always available in one place. You won't have to look around for scattered papers to find information. It becomes a time-saver as well as an organizer. When you use a phone log, you will be able to refer to all the details of your conversations.

Your clients will feel important when they realize that you are interested and organized on their behalf. When I travel between my home and my studio, I carry my phone log with me so that I always have it wherever I am.

OUT GOING PHONE MESSAGES

If you are an artist, you probably don't appreciate interruptions during your creative work sessions. Don't let the telephone run your life; let your answering machine take your calls while you are working. Put a short message on your answering machine. As an artist, you may want to do something clever or creative. I have an artist friend whose message is, "The time is NOW! Please leave a message." Don't add a musical background or your child's voice to the message on your business phone. This is unprofessional. Keep your message straightforward, short and simple.

My own message is, "This is Robert's studio phone. Please leave your name and number slowly and distinctly. And thank you for calling." I put an up-tone at the end of the last statement. It is a friendly message and makes an important request. People know their own phone numbers so well that they often say them too fast.

The most important single ingredient in the formula of success is knowing how to get along with people.
Theodore Roosevelt

Sometimes it is difficult to understand each number. When I leave my phone number, I always say it slowly and distinctly.

LEAVING A MESSAGE

When leaving a message, give your number at the beginning of the message and again at the end. Always leave your number, even if you know that the person has it. You will be more likely to get a fast callback if you leave your number.

SMILE

Answer and talk on the phone with a smile. Put a mirror in front of your telephone to help you remember this. When you smile, you sound more friendly. A friendly disposition and tone of voice help people relax and feel good, and they will like you.

STAND UP

If you are making an important call or a call in which you want to sound confident and strong, standing while you are talking may help. It increases your energy level and gives your voice more power.

Every time you make a call, look at it as a training exercise. Do the best job you can, and you will do better every time.

Be perceptive and listen to the tone of the other speaker's voice. If she sounds like she is busy and really doesn't want to talk to you right then, ask when a good time to call back would be. Suggest *two* times. This consideration will be appreciated. When you call back, the person will be more inclined to talk to you.

Salesperson:	"It sounds like you are in the middle of something, Bill. I can call you back later this afternoon or the first thing in the morning. Which would be better for you?"

SCRIPT IMPORTANT CALLS

It is helpful to script your important telephone calls. Write out what you are going to say and the anticipated answers. Try to think of all the possible responses and script out your follow-up statements. Practice your script with a friend on the phone before making the call. This will give you the confidence you need when you make the actual call.

EXERCISE

Write a script for a call you want to make, but, until now, have been procrastinating over because you don't want to be turned down or embarrassed. Practice the script with a friend a number of times. Make adjustments in your script. Then make the call and write the result in your phone log. Record all the information you need.

WARM CALLS

The easiest calls to make are what I call warm calls. These are calls that follow up a chance meeting you had, a referral, or an inquiry on your answering machine. A call that follows up an earlier meeting will give you a better chance for getting an appointment.

▸ Be flexible. Go to them if they can't or don't seem willing to come to you.

▸ Be sure that when you schedule a meeting, the decision-maker will be present.

▸ If it is a couple, be sure that both parties will be present.

▸ Be prepared to handle objections to setting up a meeting.

▸ Answer questions and then ask a question.

▸ Use questions to move the call along quickly to an appointment. Your client will appreciate your efficiency.

MAKING SALES CALLS

The best time to make a sales call is mid-morning after 10:00. People generally feel better and fresher and more receptive after they have had their coffee or tea. After lunch, a lot of people feel sluggish. Near the end of the day, many people get tired and are less receptive.

CHAPTER SUMMARY

❑ Speak clearly, distinctly, and with an upbeat tone of voice.

❑ Smile when talking on the phone.

❑ Always use the person's name during the conversation.

❑ Script your important calls.

❑ Ask questions to move the call along quickly to an appointment.

❑ Keep a log of each sales call you make. Write down all the information you can while you are talking, and fill in details immediately after the call is completed.

❑ Enter all appointments in your calendar immediately.

❑ Follow up with a reminder call the day of the appointment.

Chapter 7
Listening Power

Ask questions

Listen

Tie-downs

Listening skills

The power of the pause

Stories sell

Taking notes

It's good to shut up sometimes. Marcel Marceau

ASK QUESTIONS

Selling is a question-and-answer process.

Questions are the vitality of the selling process.

▸ Always clarify what is being said with questions.

▸ Never assume that you know what the other person wants or means.

▸ Never say, "I know exactly the kind of thing you are looking for." Rather, ask your clients to be very specific in regard to what they like and want.

Client: "I really like what those swirling colors do to me!"

Salesperson: "What do you mean, exactly?"

The question, "What do you mean, exactly?" is a great question to remember and use. It asks the client to elaborate on the statement. It lets the client know that you are really interested in the idea.

As a salesperson, you want to say the right thing, but it is more important to hear what the other person is saying. Listen attentively to your client, and then you will be able to respond appropriately. If you are always thinking about what to ask or say next, you will not hear your clients' ideas.

QUALIFYING

Early in your conversation with a potential client, it is good to learn more about the client's ability to pay for the art he is admiring. You learn this through the questions you ask and the answers you receive.

Much information can be learned through casual conversation, as well as clues such as clothing and jewelry—although these are not always dependable. Often you will find a more eccentric client who may look casual or even scruffy but is worth many millions.

Let your questions be subtle and flow freely in normal conversation. You may learn that they belong to a country club, are the owners of their company, live in a large house in an upscale neighborhood, or own a luxury car. All of these facts can be indicators that they like luxury and are not afraid to spend their money for something that they really want. One of my favorite questions is, "Do you collect art?"

If they do, they will be proud to tell you so. And if they don't volunteer to tell you what they already have, you can ask:

> "May I ask what you already own?"

When they tell you, ask:

> "Would you like to find something that complements your current collection or would you like to find something that will be new and original?"

Any affirmative answer implies that they would like to find something. If the clients tell you that they have never bought an original piece of art before, then you can ask:

> "Are you open to beginning an art collection today?"

On occasion, you may meet a person who is looking for new art. A collector who is a connoisseur of art prides himself on discovering emerging artists. If you encounter this kind of collector, you have an opportunity to introduce the newest and most unusual art that you have available. Ask:

Salesperson: "Do you have a budget?"

Client: "Why, yes, I never purchase any piece for more than $5,000."

Salesperson: "Great, then I know to show you only works that are available for $5,000 or less."

Whether your clients buy from you or not, before they leave, be sure to ask them:

> "May I contact you with future opportunities that I feel you would appreciate?"

> "May we include you on our gallery mailing list?"

> "Do you have a good friend that you know would appreciate being on our mailing list?"

Sometimes you will meet people who tell you that they are not in a position to spend any money on art, even though they love what they are seeing. Be sure to let them know that you will be ready to work with them when they are ready to begin collecting. Follow up by asking them if they have friends who collect and would benefit from your services.

Questions empower you. Only ask questions your client is capable of answering. If you ask a question a client cannot answer, your clients may feel stupid. If you make your clients feel stupid, they won't like you, and your ability to communicate will be lessened. Be attentive and ask the right questions to help your clients make the right buying decisions that they will be happy with for years to come.

▸ It is with questions that you test-close and then close the sale. With questions, you are able to get referrals after the sale is complete.

▸ Never tell when you can ask.

▸ Never talk when you can listen. When you tell people something, they may doubt you, but if they tell you something, they believe it is true.

Find out:
- Name, address, phone
- Net worth
- Annual income
- Do they already collect art? If so, what do they own?
- Travel experience: Do they take cruises or look for budget travel packages?
- What would inspire them to make a buying decision?

LISTEN

THE RIGHT QUESTIONS

The most intelligent strategy the art salesperson can use is to ask the right questions and listen carefully to the answers. Begin by asking general questions, and, as you learn more, make your questions more and more specific. Always ask for clarification. If there is anything at all that your client says that you don't understand, say, "What do you mean, exactly?"

Client:	"I really like the subterfuge in that painting."
Salesperson:	"What do you mean, exactly?"
Client:	"I mean, I really like the way the artist uses the imagery to create mystery and deception. I like art that goes deeper than the obvious."
Salesperson:	"Yes, this painting has some powerful imagery that goes beyond the obvious. It kind of grabs you and pulls you in, don't you agree?"

I think you can see how a conversation like this will help you to connect the person to the artwork. If you had just said, "Uh huh," where would you be? By asking for clarification, you slow down the conversation, increase clarity, and at the same time build trust and rapport.

THE PRIME FACTOR

The prime factor is the thing that is the most important concern to your client. It is a specific problem, a particular need, something of great interest, or a love or passion. A prime factor can motivate a person to make a buying decision. If you can find out what a person's prime factor is, you can lead the person to making a beneficial decision. Let your clients talk! Ask open-ended questions, and listen. When people ask you very specific questions and you offer specific details, you are really connecting with them.

If a new client shares information and asks questions about a work of art, you can be certain that the person is interested in learning more about the piece or the artist. One way to discover if you have found a prime factor is to watch a person's body language. If a person changes his posture suddenly, or starts taking notes or asking a lot of questions, you have probably found his prime factor. Once you think that you have found it, stay with it, ask more questions about it, and try to connect the person's interest with her prime factor.

Client:	"We have just moved our office to a new space. It is much larger and we would like to hang some fabulous art on the new walls."

It is better to know some of the questions than all of the answers.
James Thurber

Salesperson:	"Can you describe the walls?" (Listen to the answer.)
	"How large are they?" (Listen to the answer.)
	"How high are the ceilings?" (Listen to the answer.)
	"Are the walls painted white?" (Listen to the answer.)
Salesperson:	"Why don't I meet you at your office tomorrow to check out the space? I will bring a few works with me, and we can see how they enhance the space. Would 10:00 be a good time for you? Or would the afternoon be better; say, 2:00?"

Here, the client shared with the sales representative the prime factor—looking for artwork to enhance the work space. This is a real need, and a real opportunity for you as a salesperson. You will want to work closely with this client. Visit the space. Show the client artwork to learn about his taste in art. Notice at the end of the dialogue above that there is a suggestion and a question. The suggestion is to visit the office space with some works of art. Then the question follows, asking the client to make a choice between two hours.

SECOND MEETING

If a client and salesperson need to make another meeting, begin the next meeting by reviewing what happened in your last meeting.

Salesperson:	"The last time we talked, you indicated that you wanted to purchase some large paintings to enhance your new corporate office space. You also indicated that you would be interested in any discount we could offer you if you were to purchase a body of work all at one time; is that right?"
Client:	"Yes, that's right, but today our main focus is to get a large painting for the reception area."
Salesperson:	"So you are saying that today you are interested in finding one painting to enhance your reception area, is that right?"
Client:	"Yes, that's right. We have decided that it is important to act immediately and decorate our reception area. Then, at a later time, we can talk more about the rest of the office."
Salesperson:	"Very well, then, let's pick out just the right painting for that space. I'm assuming that if we can find something today that you like for that space, you will want to go ahead with it. Is that right?"

This last statement is an example of a test close. If the client says yes, then all you need to do is find the perfect solution to the client's problem.

When you ask questions and listen, you gain trust.

Build rapport by being genuinely interested in your clients' needs. Show your clients that you will go out of your way to satisfy their desires.

OFFERING DISCOUNTS

One thing you could do in a situation like this, to keep your client working with you, is to offer a discount on the painting that the client is purchasing today, if the client continues to use you to help find just the right artwork for the rest of the office at a later time. Let the client know that if more artwork is purchased from you in the future, you will be able to give a discount on those future works as well as on this purchase.

Generally, I discourage giving discounts for artworks. If you give a discount one time, then the buyer will expect it every time. I am writing this at a time when the world economy is going through a downturn. People are looking for and expecting discounts because stores are offering large sales to encourage business.

Decide in advance when you will offer a discount. The standard 10% gallery discount that I described on page 27 for repeat customers and multiple pieces is good. I discourage anything more than that. It will devalue an artist's work and reputation.

If a client asks for a discount and you don't want to give one, here is a sample dialogue to deal with the situation.

Client: "Can you offer me a discount...a better price?"

Salesperson: "Our policy is not to give discounts. We feel that it is disrespectful to the artist and her reputation. I hope that you will feel the same way."

Client: "Yes, I understand. But the economy is tough right now, and a discount will help me make a decision."

Salesperson: "Yes, we are all feeling this downturn. That is why the artwork is already fairly priced. I can assure you that this artist needs sales now more than ever. I hope you will decide to own this piece because I know how much you love it."

Client: "I will have to think it over."

Salesperson: "Please consider that the small amount of money you might save with a little discount will soon be forgotten as you enjoy the great daily pleasure of living with this artwork."

Client: "I guess you have a point. I really would like to have it."

Salesperson: "Does that mean that we should go ahead?"

Client: "Yes, I want it."

TIE-DOWNS

I hope this dialogue will help you decide how you will respond to clients who ask for price reductions. I suggest that you script a response that is clear and direct. Stand by your decision, even if it means losing a sale at that time. Don't worry. If your client really wants the artwork, he or she will be back. Or, better yet, offer to let them live with the piece for a week or two before you charge their credit card. They will most likely end up owning the work. Remember, most people buy artwork because they love it.

Listening carefully and asking specific questions will help you build confidence and rapport. We can call this "friendly selling" or "relationship selling" or "gentle selling." Asking questions and listening is the one thing that will always build trust and rapport. If you don't remember anything else about selling art, remember that.

One effective way of questioning is to use minor reflexive questions. Get in the habit of using them in your everyday conversations. Then they will slip out naturally during your sales meetings. Some sales trainers call minor reflexive questions "tie-downs," because when used at the end of a sentence, they will demand a "yes" answer or they will "raise an objection."

MINOR REFLEXIVE QUESTIONS

Can't you?	Didn't you?	Isn't it?
Wasn't it?	Aren't you?	Don't you agree?
Doesn't it?	Wouldn't it?	Shouldn't it?
Haven't you?	Didn't it?	Won't you?

When you make a statement, simply add the appropriate question at the end of a sentence to get agreement. If you don't hear the client say anything, it doesn't mean that the question wasn't heard. I have found that in most cases, the agreement is so automatic and understood that the person will not feel it is even necessary to respond. If the client really doesn't agree, you will hear about it.

EXERCISE I

Read the following statements while covering the tie-downs in the right column with a piece of paper. See if you can easily add the tie-down to each statement before you look at them.

STATEMENT	TIE-DOWN
These prints are unique,	aren't they?
Permanence is important,	isn't it?
You would like to have a beautiful collection of original art someday,	wouldn't you?

Concentration is the secret of strength in politics, in war, in trade, in all management of human affairs.
Ralph Waldo Emerson

She has really chosen the right colors to fit with her living room décor,	hasn't she?
This sculpture is captivating from any point of view,	isn't it?
You can look at this as a nice addition to your print collection,	can't you?
We do want the work properly framed to insure the safety of the piece,	don't we?
With the right frame, this work will fit into any collection,	don't you agree?
She has created a beautiful balance of color and composition,	hasn't she?

Tie-downs are easy to learn, aren't they? You are learning them right now, aren't you? It's amazing how they just seem to slip out naturally, don't they? You should practice them, though, shouldn't you? They can easily become a speech habit, can't they? When you use a tie-down, it is important to wait for the client's answer, isn't it?

EXERCISE II

Practice talking to a friend about art (or the art that you sell), using tie-downs. Continue until they feel natural. I encourage you to practice tie-downs during short conversations you have over the next few days until you get good at using them.

EXERCISE III

Now practice tie-downs by putting them at the beginning of a sentence.

It's a very distinctive piece, isn't it? Will change to…

Isn't it distinctive?

It is a fascinating piece, isn't it? Will change to…

Isn't it fascinating?

It would go well in your living room, wouldn't it? Will change to…

Wouldn't it go well in your living room?

She has created a beautiful balance of color and composition, hasn't she? Will change to…

Hasn't she created a beautiful balance of color and composition?

Listening builds trust; talking alone doesn't.

People enjoy being recognized and acknowledged. Art can add recognition, identity, beauty, enjoyment, memories and good feelings, as well as pride of ownership, to people's lives.

If you ask questions about your clients' feelings in relation to an art piece, and then listen intently, you will validate and acknowledge them. Listening is a high form of communication. By simply asking for feedback—how they see, feel and experience the artwork—you will encourage them to speak about appreciation of a piece. They will not be able to share their personal feelings about a work unless they really experience it, so they will have to see and study before they can tell you what they think. When they do, we must realize that they are not so much judging the work as expressing personal feelings about it. Always listen with an open and accepting mind. The way people see or hear is based on their own unique experience. Give them an opportunity and plenty of time to get involved in the experience of an artwork. Acknowledge your clients for their unique viewpoint and taste. This is really a creative process for you and for art buyers. After they have experienced a work, they will be more ready to own it.

BECOMING A GOOD LISTENER

The best way to become a good listener is to *not talk*. I remember a time when I was shopping for a new car. The salesman just listened to me. Didn't say much, didn't ask much. I remember thinking to myself, this car salesman is really different. When he did say something, I trusted what he said. I felt he knew and cared.

There is no faster way to build trust than by listening. There is no faster way to undermine trust and annoy a person than by talking too much. When you listen intently to a person, it shows that you genuinely care, and that person's self-esteem goes up. The person feels more worthwhile and important as a human being. When you show that you are happy to be listening, you create a bond of trust and affection. The more trust and affection a person feels toward you, the easier it will be for her to be in agreement with you.

By listening in a genuine, caring way to everything a client has to say, you can make the person feel terrific. Begin practicing every day in every area of your life, not just when you are selling.

DON'T INTERRUPT

We listen to what we value, and we ignore what we don't value. The fastest way to turn a person against you, or hurt her feelings, is to ignore what she is saying. Even worse is to interrupt the person in the middle of a sentence or thought; it's like an emotional slap in the face. When this happens, the process of building trust or affection is likely to be terminated.

LISTENING SKILLS

It is very important that you become a good listener.

GUIDELINES TO BECOME A GOOD LISTENER

- Listen intently to every word the person is saying.
- Look at the person. Give him steady and warm eye contact. Don't be shy, but don't stare him down.
- Be genuinely interested in what she is saying.
- Listen with the intention to assist the person best to meet his needs or desires.
- Ask only appropriate questions to gain the information necessary for you to respond or act in a meaningful way. Listen carefully to the answers.
- Let the person know that you are listening by paraphrasing what he just said to you.
- Take notes when appropriate so that you can refer to the information later. When a person sees you doing this, she will know that you are listening carefully and that you want to remember what is being said. You might want to explain to them why you are taking notes.
- Resolve to become a good listener. Practice on every occasion you can, be it a sales situation or everyday conversation.
- Seek out opportunities to make others feel important by listening attentively to what they say.
- Remember that you have two ears and one mouth. Learn to listen twice as much as you talk.

One of the best listening skills is simply to pause before replying. When your client finishes saying something, rather than jumping in immediately with the first thing you can think of, take a moment (two or three seconds) and pause quietly before you answer.

THE BENEFITS OF PAUSING

▸ You avoid the risk of interrupting if your client is just gathering her thoughts.

▸ If you don't answer right away, your client may continue speaking and give you more information to help you meet his needs and make the sale.

▸ Putting some silence into a conversation compliments the person. Your client will know you are carefully considering what is being said. You are silently saying that what is being said is important to you and worthy of quiet reflection. You make the person feel more valuable, and this raises his feelings of self-esteem.

▸ It appears you are letting the statement or question soak into your mind.

▸ With some time to consider what was said, you won't be immediately looking for something or anything to say. You will be better prepared to consider the situation and make the appropriate response.

▸ Pausing will show that you are an exceptional conversationalist.

APPLYING LISTENING SKILLS TO ART SALES

There is no faster way to irritate a potential client than by talking too much and listening too little. According to the Purchasing Manager's Association of America's annual survey, the biggest single irritant that potential buyers experience in dealing with salespeople is, "They talk too much."

Salespeople typically like to talk. Sometimes it is out of nervousness; sometimes it is to avoid selling. When working with a potential buyer, it is important to listen—not just listen so that you can respond. Listen carefully to find out the client's needs and desires. What does the client really want?

A good practice is to try to answer questions and then make an inquiry. Pause. Wait for an answer. Allow the client to have a chance to think. Don't rush the client. Don't talk so fast that the client will have to speed up just to be able to say something.

Match the pace of your client. If your client talks slowly and deliberately, adopt the same pace. If your client talks fast, then speed up to match it. You can always add pauses if the pace becomes too fast for you. Never say more than three sentences in a row without pausing.

THE POWER OF THE PAUSE

Perhaps there is only one cardinal sin: impatience. Because of impatience we are driven out of Paradise; because of impatience we cannot return.
Franz Kafka

The most successful sales people know how to ask questions and then listen.

COUNT TO THREE

When your client stops talking, pause before responding. Get into the habit of counting to three. A count-of-three pause gives you a chance to absorb what has been said. It shows the client that you are listening and that you value her words and thoughts.

- ▸ It shows that what has been said is worthy of consideration.

- ▸ It helps ensure that you will not interrupt the client.

- ▸ It gives you a chance to think of the most appropriate response.

It is imperative that you say something after you pause. A pause without a reply is very rude. The silent treatment will destroy any rapport you have established. Some people use silence as a means of controlling a situation where two people are not in agreement, but it will only cause discomfort or resentment in the other person.

- ▸ Never sound sarcastic, cynical, argumentative, or in any way angry.

- ▸ Never cut a person off or try to change the subject.

- ▸ Never look uninterested or bored.

- ▸ Don't try to sound or look "cool."

- ▸ Be calm and sincere.

Try to respond honestly and in agreement as much as possible. Help the client see that you are there to understand and assist. Before responding with your point of view, ask at least one clarifying question. This will give the client a chance to rephrase or reevaluate her thoughts.

Tell the client in your own words what you think you heard:

> "Let me see if I've got it right. What you are saying is…"

Or, you might say:

> "If I understand you correctly…" and then repeat or rephrase what you think the client said.

Both of these responses demonstrate that you have been attentive. They show that you are making an effort to understand, and that you are genuinely interested in the client's thoughts and feelings. Look directly and gently at the client while he or she is talking. Don't stare. Smile. Be receptive and polite.

By becoming a good listener, you become good company. People will want to be around you. Clients will feel welcome and relaxed when they are with you. Remember that listening to a person builds trust and affection between the two

of you. The more you practice listening skills, the more your client will appreciate your opinions and consider your recommendations.

As you practice these skills, you will gain self-discipline and confidence when you communicate with your clients. It is said that our minds can process 500 to 600 words a minute but we can only speak about 150 words a minute. It takes real effort to stay focused on what a person is saying. If you are not disciplined in conversation, your mind will wander in a hundred different directions. Ask for clarification. Your client will respect you for it.

EXERCISE

Pair up with a friend and carry on a conversation about art. Pause for a few seconds before you respond to each question or statement. Do this until it feels natural. Practice pausing in your conversations during the next few days until you get used to it. It may feel strange at first, especially if you are a person who is used to talking fast and has a proclivity to be impatient. If I just described you, this is the very kind of practice you need. Try it, and watch your relationships improve.

Stay focused and listen carefully to what your client has to say.

STORIES SELL

Most artists and their works have some kind of story. Some actually depict a story—a biblical story, a historical story, a personal story, for example. There is a story behind the way or reason the painting, sculpture or print came to be made. There is a personal story behind the artist's commitment to make the work. All of these stories will add a high degree of interest to the work. If you know the story, tell it. Only tell the story to a client who wants to hear it, though.

Client: "I don't understand what this is about."

Salesperson: "There is a story here. Would you like to hear it?"

Client: "Why, yes."

Salesperson: "Would you like the long version or the short version?"

Client: "I've got time. Give me the full story."

Now you have permission to relate the story. If you find that the client is starting to lose interest, finish up the story quickly. At the end of the story, you might say:

Salesperson: "Now that you know the story, the painting makes a lot more sense, doesn't it?"

As a salesperson, try to find out the stories behind the work you represent. Make good notes so that you can tell the stories well.

If you are the artist, you already know the stories. Think what might be of interest to a prospective buyer. Then, with the client's permission, tell the stories.

PUT THE STORIES IN WRITING

A few years ago, I exhibited 60 watercolor paintings in a one-man show. There was so much work that I was concerned that people would get into the exhibition space and feel overwhelmed. Guests might not take the time to really look at the work. So I wrote a short story about each work and mounted it on the wall next to each piece. When people came to the show, they took their time looking at the paintings and reading the stories. It took some time to write and mount the stories, but it was well worth the effort. I'm sure that the stories helped sell paintings.

TAKING NOTES

One of the best ways you can demonstrate to your clients that you care and that you are listening is to take notes while they are talking. If a client objects for some reason, simply tell the person that you always do this so that you won't forget something important. Tell the person that it helps you listen carefully and remember what is being said.

The first time I wrote during a sale was with a corporate client. The buyer came to my studio and began looking at works. When he found something that he liked, I wrote down the title of the piece and its price. I knew that there was a budget and I had an idea of what the budget was. As he was looking, more and more titles were added. He selected paintings, original prints, and even a poster. I couldn't believe that he would buy all of the works that he liked. I expected that we would go through the list and eliminate some. I was sure that if he selected all of the pieces he liked, it would be over his budget. But of course I didn't say that. He saw that I was writing notes. After going through many works and selecting quite a number, he said to me, "Let's see what I've got." He asked me to add up all the prices and give him a total. To my great surprise, when I closed the sale, he took them all! That is exactly why you take notes.

Write down particular facts that the client gives you. Write down the client's likes and dislikes. Your writing also will help you pause during the conversation. You can use your writing time as a pause and then follow up with a question. Writing also helps you be less intrusive in your client's space. Your client will have a chance to look more deeply at the artworks while you occupy yourself with writing. There are other benefits too:

- You will remember what the person told you.

- Writing makes the words communicated more "solid," more important.

- It will help you to not forget anything important.

- You will be able to keep an account of what they like.

- You will be able to make an easy transition to writing up the order.

- You will be able to review your notes later to prepare for a future appointment with the client.

- You will be able to apply what you learn to other clients and other situations.

- You will have a record to refer back to at any time.

- You will be able to review with your client what has been said and agreed upon.

In some situations, writing may not be appropriate or even possible. But if you can do it and you can make it feel comfortable and natural, it will help increase your sales.

CHAPTER SUMMARY

- ❏ Selling is a question-and-answer process.

- ❏ When your client answers your questions thoughtfully, it means she is interested in buying.

- ❏ Qualify your potential buyers as soon as you can.

- ❏ The most successful salespeople know how to ask questions and then listen.

- ❏ If you listen very carefully to what your client asks and says, you will discover his prime factor.

- ❏ If you focus on the client's prime factor, you will build rapport and ultimately make the sale.

- ❏ When you meet a client for a second time, always review what you discussed or decided at the end of your first meeting before beginning the second meeting.

- ❏ When clients know that you are listening and that you care about their needs, you build trust.

- ❏ Never tell your clients that you know just what they will like. You don't!

- ❏ Always ask questions your client can answer.

- ❏ Use tie-downs at the end of sentences to get agreement or raise objections. Practice them until they slip out naturally.

- ❏ Give your clients an opportunity and plenty of time to experience a work of art personally.

- ❏ Validate and acknowledge your clients for their unique viewpoint and taste.

- ❏ Listening will help your client feel more confident when making a buying decision.

- ❏ Paraphrase the important things your client says.

- ❏ As a salesperson, know the story behind a work.

- ❏ With the client's permission, tell the stories that you think will be of interest about the works you are selling.

- ❏ Always end your story with a question.

- ❏ Get in the habit of pausing for a few seconds during all your conversations.

- ❏ Never interrupt a client who is talking to you. Wait to be sure she is finished.

- ❏ Plan always to have your "notebook" handy when working with a serious buyer.

- ❏ Start writing from the beginning of the meeting.

- ❏ Take notes during the meeting so it becomes an easy transition to writing up the order.

Chapter 8
Connections

18 ways to connect clients to the art

"Anything's possible" mental attitude

Either you are a creature of circumstance or the creator of circumstance.
 Robert Cavett

18 WAYS TO CONNECT CLIENTS TO THE ART

Help your clients establish a strong personal connection with the artwork that attracts them. Some of these connections are rational; most are emotional. Use them as bridges. Try to find out what the strongest connection is between your client and the artwork that he is admiring. Go with that. Then add others if you feel it necessary.

Whatever a person thinks about a piece, it is her opinion—it is not right or wrong. It doesn't matter how **you** feel when you are closing a sale. Train yourself to connect a person to the piece emotionally or rationally by asking questions. Always satisfy questions about technique, the artist, the medium, the size, etc., and then move to connect the buyer with her feelings by asking another question. People buy art for emotional reasons. You could say,

> "See how the artist uses the medium to bring you into the image (story, situation). Can you feel the emotion, the spirit, the passion here?"

Of course, these questions and the ones that follow are only given as suggestions. Use your own creativity to know just what to say that will be appropriate in each situation. Put these ideas into your own words; don't try to memorize the examples. Remember always to use the ABC's of closing—Always Be Closing (Chapter 9)!

1. OPINIONS

Buyers have their own opinions. They don't know how you feel, and there is no need to tell them unless they ask. Many clients don't care how you feel. Most people have very strong opinions about art, what they like, and what they don't like. Don't try to change them. If you happen to agree with their opinion, expressing your agreement will help strengthen their opinion. Often, people feel deeply but will not trust their feelings because they may not know a lot about art or the particular art they are viewing. You can help validate their feelings by reassuring them that those feelings are relevant. If they ask you how you feel, tell them—but only if they ask. There is no need to volunteer this information, especially if it is not about a favorite painting or artist of yours. What appeals to you will not necessarily appeal to someone else.

When you are dealing with a couple, they need to be able to talk alone. Give them a safe space to do that. Either leave them with the piece and walk out of earshot, or leave them alone in the viewing room. Before you exit, however, review with them what they mutually like.

2. OPTIONS

Here are some questions you may wish to use to find out what your clients' options are:

> "Where do you see this hanging?"

"Where will you display it?"

"Who will see it?"

"How will it be appreciated?"

"If you were to own this piece, how would it harmonize or contrast with the other art you own?"

"Can you visualize this in your home or office?"

This last question is a strong suggestion to your client to actually picture the place where it will be installed. When you ask this question, be sure to wait for the answer. If he answers yes, that is a successful test close (Chapter 9).

3. UNDERSTANDING

Clients may not be aware of the artist or the work. If you are the artist, you are the best source to enlighten them. First, politely find out if they are interested in learning more about the work or the artist. Second, only offer as much info as they really want to know. Sometimes, when clients learn more about how a work was made or what it means, they will be more interested in owning it. Here are some more questions you might ask:

"Are you familiar with this artist's work?"

"Would you like to hear some facts about the work?"

"Would you like to know how this piece was made?"

"Do you know how this artist was trained? It is quite an interesting story."

4. LEARNING

Many art students, young and old, buy art because it inspires them or will teach them how to make their own work better. They will buy it so that they can study the technique or the way it was made.

We can also learn about ourselves from a work of art. An art piece can inspire us to look deeper into ourselves, to live more fulfilling lives.

It doesn't hurt to know something about art history. If you know your art history, you can offer information that will make the piece relevant in a historical context.

"What do you think we can learn from this work?"

"Can you see the influence of the (name the art history period such as the impressionists, the realists, pop art, Baroque art, Renaissance art, etc. in this work?"

5. REMINDING

This is probably one of the most powerful connectors. It is also one of the easiest to speak about with a client.

> "What does this piece remind you of?"

> "What sport/person/landscape/travel experience/event/place/ hobby/occupation/book/movie/musical composition/play/ opera/family event does this piece remind you of?"

Memory is a very powerful reason for people to buy art. A portrait of Johnny when he was 10, Dad when he retired, Mom when she was president of the Floral Society—all are reminders. A portrait of the family pet, the horse, or the boat will hang as a proud and sentimental reminder of the good times. The painting of a beach in Hawaii will remind the family of their vacation. The painting of a waterfall in Yosemite Valley will remind the family of the awesome inspiration they felt when they visited this popular national park. People love to buy art that reminds them of a person, a passion, a positive experience. Here are some sample questions:

> "Doesn't this remind you of your travels to _____?"

> "Wouldn't this be a perfect reminder of your holiday?"

> "Doesn't this remind you of some of the finest craftsmanship in the world?"

> "Doesn't this remind you of [name another great work of art]?"

> "Do you play (name a sport, musical instrument, or game)?"

> "Have you ever visited Venice, Italy? Spent time in Paris? Been to the Louvre Museum?"

> "Have you seen the film about ____ or read the story of ____?"

6. SEEING

A person can see a metaphor in a butterfly, a phoenix, a tower, a sunset, a sunrise, a flower. For example, a person might see the lightness of being in a bronze sculpture of a dancer. Of course, the visual arts are all about seeing. Seeing can take place on many levels. Here are some sample questions to give you ideas:

> "What do you see in the work?

> "What colors … images … forms … textures … compositions … melodies … rhythms do you see?"

> "Do you see the beauty…the simplicity…the craftsmanship … the delicate care of the artist?

"Do you see the drama … the perfection?"

"Do you see the humor?"

"Do you see the metaphor?"

"Do you see the [name the color]?"

7. ENTHUSIASM

When people are "hit" by an image, they will most likely voice some kind of exclamation. As the seller, you will be ready to notice the sounds, words, or movements that they make. It will be a sure signal to you that they are interested in the work. If you also feel that enthusiasm for the piece, it will help you bond with them and move toward the state of "being in agreement."

8. FEELING

A client might sense the emotional concerns or values of the artist or feel a deep emotional connection with the imagery. An artwork can stir up the emotions of its viewer. Go to an art museum sometime, sit quietly in a gallery and listen to the comments people make to each other as they view the works of art. Take notes.

"How does it make you feel?"

"How do you feel when you experience this piece?"

"What other relevant experiences have you had?"

"It sure beats a blank wall, doesn't it?"

"Can you feel the drama?"

"Can you feel the space?"

"How does the color feel?"

9. EMPATHY

Your client might have sympathy with the emotional or political position of the artist. What was the artist feeling? The artist's personal vision of the world is revealed in the piece, and your client might relate to it. The artist may have a personal mission to educate the public on some social or political issue. Your client may feel empathy for the artist's view. This is a strong connector.

10. LIKE OR DISLIKE

Find out what your client likes and dislikes. People buy what they like. They don't buy what they don't like. It is that simple.

Never be afraid to find out what people don't like. You need to know. Every so often, when you find out that people don't like something about a work, it is because they don't understand it. On occasion, when you explain a work of art, it will change their perception. Often, dislike is a result of either lack of knowledge or misunderstanding. If a particular client frowns or mentions something that she doesn't like, ask her about it. Sometimes, when she talks about it, a new understanding will come to light and her negative opinion will be turned around. It is better for your clients to have their own insight than it is for you to try to explain to them. Rather than explain, ask questions that will lead them to a more clear understanding. It will make them feel validated and in control if they make their own discoveries.

11. HUMAN CONNECTIONS

How do we relate as a member of the human race? Any time a figurative image is used in an artwork, there is a connection to its viewers. Look at art through the ages. Walk through the Louvre in Paris or the Metropolitan Museum of Art in New York City. Notice the many references to human imagery. It is a subject that has been used since time immemorial and will continue to be used in art.

> "Look at that lightness of being in the dancer's form."
>
> "What a powerful stance!"
>
> "What a gesture of defiance!"
>
> "Look at the human dignity and strength in that image."
>
> "Can you see how the strength of the figure is enhanced by the size and mass of the sculptural form?"
>
> "Notice how the artist has captured a vivid moment of great feeling and spiritual passion through the physical form."

12. GOVERNMENT AND POLITICAL CONNECTIONS

Governmental bodies will commission works for government buildings and landscaped gardens. Political leaders will commission portraits. This avenue alone can be a source of repeat sales once you are established as an artist or dealer.

13. EXCITING

People can get very excited about an art piece. Many will openly express that excitement. Here are some sample questions:

> "What is it that grabs your attention?"
>
> "What excites you most about this work?"

There are many connections —all reasons for people to trade money for artworks. Be aware of these connections, and use the ones that apply to the work you are selling.

"Why do you think it excites you so much?"

"I can see your excitement; what is it that grabs you?"

The image could be an exciting battle, a sporting event, a fight, a celebration. The human body can be exciting. Animals can be exciting. Colors can be exciting. Compositions can be exciting.

14. PASSION

Help your client experience the passion of the artist, the artist's conviction. When an artist feels deeply about a cause or issue and puts that out to the world through his art, it can result in powerful work.

"You can sense the strong passion this artist feels toward his people."

"Do you share the passion this artist feels for the hungry?"

"Can you feel the tender passion she has for war victims?"

15. RELIGIOUS CONNECTIONS

Each religion has specific art traditions. When clients have strong religious beliefs, this can be the reason they want to own a work that relates to that religion or reminds them of their affiliations: Baptist, Buddhist, Christian, Confucian, Episcopalian, Greek Orthodox, Hindu, Islamic, Jewish, Lutheran, Methodist, Protestant, Roman Catholic, Zen Buddhist, etc.

Art has been used in places of worship for many centuries. Religious institutions are an important market for the world of art. Often, artworks are commissioned by a religious institution. An artist will be hired to make a "cartoon" for a larger piece; the commission will be granted when the preliminary study is approved.

If you represent an artist who does this kind of work, you will sell the idea with the preliminary cartoon. Usually an artist is given an advance partial payment and then full payment when the commission is completed and delivered.

16. ETHNIC CONNECTIONS

Look for ethnic connections, cultural identities, national loyalties, racial connections. People like to be able to identify with their own ethnic, national or cultural roots.

17. SENSUAL CONNECTIONS

Connect your clients to art through their senses—hearing, touch, sight, taste, smell; seeing the sound of the ocean, hearing a symphony of light, tasting the

colors, smelling the passion, feeling the texture, touching the heart. Be creative; ask questions that will open up their senses.

18. SPIRITUAL CONNECTIONS

Here is a beautiful and powerful message: When an artist is communicating her personal experience of the universe, God, the supreme power, spiritual energy, the light of life, the soul, the life force, human spirituality, the result can be very moving. Art of this nature can be a great source of personal inspiration when displayed in a home or public place. Look at the many works of art that have been created through the ages depicting spiritual and religious stories.

Never go into a selling situation expecting to be rejected. Remember to keep an APMA—"Anything's Possible" Mental Attitude. No matter how many clients have walked away, that doesn't mean your next client will do the same. Look at your batting average. If you sell to one in 10, then each client who doesn't buy will be just one of the nine you must approach to receive the sale.

Remember: You don't want to sell to people who don't want the art you represent. Help people own what they really want. Not everyone will want what you are selling.

Look at your selling efforts as an adventure. As you practice selling, you will become more comfortable with the process.

"ANYTHING'S POSSIBLE" MENTAL ATTITUDE

CHAPTER SUMMARY

❏ Do your homework so that you know what questions to ask.

❏ Learn as much as you can about the art and the artist.

❏ Ask questions that will enhance your clients' enjoyment and knowledge of the works and the artists who created them.

❏ Keep an APMA—anything's possible mental attitude.

❏ Only help people own what they really want.

Chapter 9
Closing

Test closing

Closing a sale

The "puppy dog" close

What selling art requires

Never continue a job you don't enjoy. If you're happy in what you are doing, you'll like yourself, you'll have inner peace. And if you have that along with physical health, you will have had more success than you could possibly have imagined. *Johnny Carson*

TEST CLOSING

A test-close is a question that tests the client's involvement in the artwork to see if she is ready to make the commitment to own it. There are many ways to test-close a sale.

CONDITIONAL QUESTION

A conditional question works very well. If . . . then . . . ?

> "If you were to own this piece, where would you want to hang it?"

ALTERNATIVE CHOICE

Another great way to test-close is to use an alternate or choice question.

> "If you were to own this piece, would it be for your office or your home?"

Here are some examples of test closes. You can begin using them to assess your client's interest before you try to close the sale:

> "If you were to get this painting, would you want to keep it in this frame or would you want to have it framed yourself?"

> "Can you visualize this hanging in your living room?"

> "This would be a great reminder of your wonderful vacation here, don't you agree?'

> "Are you seriously considering owning this print?"

> "I would be delighted to see you take this home; I can see you really love it, don't you?"

> "Would you be taking it with you, or would you want me to ship it to you?"

> "If you had plenty of money, would you take advantage of this offer?"

WHEN THE CLIENT DOESN'T KNOW THE PRICE

Often, I have shown work to people when the price is not listed on the back or next to the piece. They like the art and take the initiative to ask about the price. When someone asks you about the price, you know that she is considering owning the piece, and all that is standing in the way is money.

Sometimes, however, people who like a work of art are only curious about the price. No matter what the price, it is likely to be too much. In this case, I ask them to consider first, what they may *have* to pay for the piece. Then I ask them what they would be *willing* to pay for it. In each case, tell them to keep the answers to

Ask and you get; don't ask and you don't get.
Hank Trisler

themselves. If you can, have them write down the answers to these two questions. If they write the amounts down, then you can write the price down so that they can compare. If your price is the same or lower, you may have a sale. If it is not much higher, you can ask if they would be willing to go up a bit. Remember, if you just tell them the price without asking these two questions first, most likely anything you say will be too much.

I was doing a watercolor workshop in Bali, Indonesia. A Dutch couple at the resort where we were staying found out that I was the teacher of the workshop. They were interested in seeing my work. I made an appointment with them one evening to show them some of the watercolor paintings that I had done on our trip. They saw one that they both liked and asked me if I would sell it and how much it would be. I asked them to discuss between themselves in their own language what they would be willing to pay. They did, and then I told them the price. I was sure that it would be more than they had discussed because the art in Bali was so reasonably priced. But, much to my amazement, the price they had in mind was exactly what I wanted. The next day they gave me traveler's checks and I gave them the unframed painting. Be prepared to sell anywhere and at any time.

Here is a sample dialogue to help you script your own.

Client: "How much is this one?"

Salesperson: "Is that the one that you are interested in?"

Client: "Yes, I really like this."

Salesperson: "Before I give you the amount, would you please think how much you would have to pay for it, and then how much you would be willing to pay for it. If you could just write those two numbers down on this piece of paper. Don't let me see it."

While the client writes down the numbers, you, the salesperson, write down the price on another sheet of paper and then say:

Salesperson: "So now I am going to show you the value, and we can compare your numbers to it."

Salesperson: "It looks like we are pretty close. Do you want to go ahead?"

Or, if your number is a bit higher than your client's, say:

Salesperson: "This number is just a bit higher. Would you be willing to go up a bit? Just remember how much you would like to own it."

Client: "Yes, I'm going to take it."

CLOSING A SALE

If you don't ask the client to buy, she probably won't buy.

The closing question is the question that asks the client in a very direct way to own or invest in the work of art being admired. It is amazing how many people who want to sell art don't ask their clients to buy. If you don't ask your clients to buy, they probably won't. It is your loss, but, more importantly, it is their loss.

A closing question usually must be asked for a sale to take place. The answer to a closing question will either seal the agreement or raise an objection. If an objection comes up, you take care of the issue and close again. Once in a while, a person will come up to you with checkbook in hand and ask you to figure the tax. That is rare and most likely will happen when the art is priced under $500.

ASKING THE QUESTIONS

You must learn to ask a closing question in a natural and easy way. Ask it with a smile, and when rapport is very high. Ask a closing question when you recognize that your client is interested in owning the artwork and may be ready to make that commitment. Following are some friendly closes. They are short, simple to learn and easy to use. If you don't memorize anything else from this book, learn a few of these. Practice them with a friend until you are comfortable saying them. Let them innocently, freely and gently slip out of your mouth at the appropriate time.

12 EASY-TO-LEARN CLOSES

- Would you like it wrapped?

- Do you want it framed?

- Is it yours?

- Are you going to take it?

- Are you taking it with you?

- Well, if you like it, why don't you take it?

- Can you take it with you?

- Is that it?

- Shall we go ahead?

- Is that the one you want?

- Shall we do the paperwork?

- Did you want to use a credit card or a personal check?

TONE OF VOICE

Just as important as the words you use is the tone of voice in which they are delivered. Speak with honesty and sincerity in your voice. Be gentle and kind when you are asking for the sale.

SILENCE IS GOLDEN

When you ask a test close or a closing question, it is imperative that you wait silently for a reply.

- A test-closing question will tell you whether a person is ready to make a decision.

- A closing question will ask your client to make a decision to buy or not to buy.

When you ask one of these questions, it is very important to pause until your client answers. It may take her a good amount of time to reply. She will want to consider her answer carefully. You, as the artist or salesperson, must remain silent until the answer comes, no matter what—even if it takes five, 10, or 15 minutes. Usually the answer will come in the first 10 seconds, but not always. Even 10 seconds can seem like a long time. You are anxious to hear the answer. She is not anxious to spend her money. She may want to own the art very much, and you know that, but the money can get in the way. She may not be sure she is getting the best price. She may not be sure she wants to own that piece. She may not be sure she wants to spend the money for this. There can be all sorts of uncertainties that come into making that decision. You must wait for her to answer. Don't let yourself break the silence. Remember: It is her turn to answer the question. Just stay quiet and wait for the answer.

EXERCISE

Pair up with a friend and ask each other closing questions. Smile warmly and ask with genuine interest. The person acting as the buyer must wait at least 10 seconds before giving an answer. The one acting as the salesperson must always wait silently for the partner to answer. Be aware of what is going on while waiting for an answer. Do you feel tension in your body? Fear of rejection? Apprehension? Anticipation? What thoughts are you having? Even though you are play-acting, the real emotions that you would experience in the situation will be there. Your mind and body are conditioned to react. Look at your partner's face with great interest when asking these questions. After you do the exercise, report what you saw expressed on the other's face. Become aware of your own feelings and report these to your partner. With practice, you will find that self-awareness can override feelings of fear or anxiety. Repeat the exercise with the roles switched. Remember that awareness is the key.

If anything is worth trying at all, it's worth trying at least 10 times.
Art Linkletter

Some people say that it is helpful to synchronize your breathing to that of your client.

KEEP A NEUTRAL POSITION

If you have some anxiety, it will be communicated. Detach yourself from the outcome. Stay neutral and wait for the answer. Be willing to accept a yes, a maybe, or a no. Sometimes that is difficult in a real situation when there are thousands of dollars resting on the client's decision. You will have a better chance of succeeding if you maintain a neutral stance. Whatever the client says, it is okay. Even if the client tries to avoid answering by saying that he wants to think it over or needs to talk it over, or is not sure, stay neutral and accept his answer. Then you will be able to respond appropriately.

TECHNIQUES TO REMAIN CALM WHILE CLOSING

▸ Examine with interest the other person's face or the artwork. Think of it as a threesome—the client, you, and the artwork. You can move your attention from your client to the work and back to your client while he is making up his mind about what to say.

▸ Counting silently while waiting may also help keep you neutral. Make it a game and see how many seconds it takes the client to answer your question.

▸ Breathing while selling will help you stay relaxed. Being aware of your breathing when you ask the closing question will help you remain neutral. Put your attention on the breaths you are taking. Some people say that it is helpful to synchronize your breathing to that of your client as a way of increasing rapport. It is reported to be a very subtle and effective way to establish a strong communication with another person. Take a moment here, and just breathe and be aware of your breath. Feel the calm that aware breathing can produce in your being. This can also help you establish the peaceful atmosphere needed for an optimal closing.

THE QUESTION

Closing is the most important part of the selling process. Most sales take place because the representative asks a closing question. Don't expect your client to buy without hearing a closing question. It can happen, but it is rare.

The important thing is to make a safe, relaxed space in which your clients can make a decision. Become aware of your hidden feelings, your fears and anxiety. If a "giving-up" impulse comes, let it go. Do not give it power or feed it by fearing it.

There may also be cultural differences when asking closing questions, such as position of bodies to each other, eye contact, etc.

▸ Keep your hands out of your pockets and at your sides. Hands in the pockets present an image of apology or inferiority. A pocketed hand can also

communicate subliminally that you have something to hide. You may think it looks cool, but it doesn't communicate that message in a selling situation.

▸ Don't hold your hands in front of you or behind your back.

▸ Don't fold your arms. Folded arms communicate superiority. You want to remain neutral.

Ask the closing question when the time is right. Like water boiling in the pot on the stove, it is as hot as it is going to get. As soon as you remove the pot, it will begin to cool. If you leave it off the stove for a day, it will be as cold as if it were never heated up at all. If you don't ask the question when you know the client is ready, the person is likely to forget why he was so eager to make the purchase in the first place. You will lose the sale, and the client will lose the opportunity to enjoy that work of art for years to come.

A WEAK CLOSING QUESTION

An example of a weak close is, "Well, what do you think?" This does not ask the person to make a buying decision. The answer to this question will probably not be a yes answer or an objection. It will sidetrack your closing attempt. Never ask this question!

DEFINITION OF A CLOSE

A close is a question asked to assist the client in making a decision from which the client will benefit.

Remember, you are interested in gaining clients and collectors more than art sales. We are not trying to con anyone into buying art. A con man will sell anything to anybody. He doesn't care what happens after the sale. Professional artists or art representatives will only sell what they truly believe will benefit their clients.

WHEN TO CLOSE

▸ When the pace feels relaxed

▸ When the client shows great interest

▸ When the client begins to ask questions

WHERE TO CLOSE

Anywhere	At the golf course	In the parking lot
In the gallery	In the home	At their office
At an art fair	In your studio	

Don't assist a person in making a decision that he or she will later regret.

ALWAYS BE CLOSING

The ABC's of closing are Always Be Closing, which means that each step of the selling process is a step toward closing the sale. Look at it as if you were going down a stairway with your client. You will know you have reached the bottom of the stairway when you ask a closing question and the buyer says yes and owns the work of art. I like the analogy of going down a stairway better than climbing stairs. Climbing implies effort. Let the whole process be comfortable, gentle and as effortless as possible. When you can make the experience of selling art fun and effortless, you will be very successful.

The "puppy dog" close is based on the idea that if you take a puppy home for a few days, you will end up falling in love with it and buy it. This is a great way to sell art, as well. Many galleries will let you take a piece home for a week or two with the idea that you will want to keep it after that time. The best way to introduce this close is to offer a hesitant client the opportunity to live with the art for a few days, with no strings attached. If the client agrees to try it, at the end of the trial period he will most likely buy it.

You need to ensure that the client will not run away with the art by "swiping" her credit card for the full amount of the sale. At the end of the trial period, if the client brings it back, you will credit the full amount back to the account. If the client keeps the work, you have already been paid.

I have also managed to sell quite a bit of art using the puppy-dog close with friends. On occasion, I have let good friends borrow multiple works unsecured for a period of months. Their homeowners' or businessowners' insurance covered the works while they were in their possession. About 75% of the time, they ended up buying.

As an artist, I can always use more storage space. Occasionally, friends have blank walls in their new homes or offices. They ask me if I would like to hang some paintings on their walls. I always know that this is a great opportunity to sell art if I know the people well. They initially think that they will just be borrowing the art, but invariably they want to keep it.

RENTING OR LEASING ART

Another way to use the puppy-dog close is to rent or lease artwork to prospective clients. Many corporate offices like to rent rather than buy. Some will rent while they are considering buying. This can be a way of increasing your month-to-month income while the client falls in love with the work. In any rental situation, discuss the possibility of an eventual purchase. You can explain and negotiate your terms. Artists and rental galleries can offer to deduct a portion of the rent paid from the selling price if the client decides to buy after having rented a work of art for a period of time (usually not more than a year).

Art leases to offices can also turn into residential sales. People who work in an office often want to take the art home. This works well when you are selling original prints, serigraphs, lithographs, etchings, woodcuts, or sculpture castings, where multiples are available.

Be sure that all lease or month-to-month rental agreements are in writing. (A sample rental/lease agreement can be found in the appendix of this book.) Make sure that the works are insured while they are in the possession of the lessee. Either you or the client will be liable for damage or theft of the art. The insurance fees can be part of the lease, or they may be included in the homeowners' or businessowners' insurance policy. All of these factors must be discussed and agreed upon in writing.

THE "PUPPY DOG" CLOSE

Have a client take an artwork home, and inevitably he will buy it.

For more information on leasing artwork, see *Art Marketing 101* by Constance Smith, available at artmarketing.com.

PAYMENT PLANS

Since art is a luxury item and can be expensive, many buyers may not have the cash ready to spend. Most galleries have payment programs to help customers finance their purchases. These programs vary greatly and are usually tailored to the individual collector. Since paying off credit-card debt can be very expensive, a gallery can make a sale more attractive to a client by offering terms with low interest or even no interest over a short period of time (usually limited to one year).

If a person is not paying for the piece all at once, it is important for the artist or gallery to retain possession of the work until the piece is paid for in full. This avoids the complications of trying to take back a work that has not been completely paid for or trying to get overdue payments for a work that the client has already obtained. This is true no matter who the client is. With rare exceptions, a client should not take possession of the artwork until it is completely paid for.

As an artist, I keep records of people who are buying my work on time. When they send a payment, I acknowledge it with a postcard. Be sure to update your payment-due file, too. When the painting is paid for, I see that it is delivered to them promptly.

WHAT SELLING ART REQUIRES

Selling art can be thought of as an art form. Indeed, it requires creative thinking just as creating art does. Imagination, reason, emotional involvement, good judgment, commitment, expertise, finesse, and skill are all involved in the selling process. Most artists find the thought of selling their work far outside their willingness to participate. But I have found that the process of selling art can be fun, creative, exciting, and exhilarating. It has made me a better painter and put me in charge of my own career as an artist.

DEFINITION

The "art of selling art" is simply the process of developing rapport with a potential, qualified client who will benefit from owning or using the art you represent and then having the client commit to making a buying decision.

One of the most effective ways to complete a sale is to engage in a dialogue with the potential client in which you ask questions that will lead to a buying decision. Representatives who are not trained in selling art usually try to *tell* their clients about the works they represent. Remember: "Telling is not selling!" My experience has taught me that clients might politely listen for a minute or so, but as the representative continues to talk, they become more and more disinterested. By telling, you will end up losing their attention and, of course, the sale as well.

People don't like to be told. People would rather tell you. So the way to get your clients really interested in owning what you have to sell is to ask them questions so that they can tell you their thoughts. The more they tell you, the more interested they will become.

ENERGY

Selling requires energy. If you have good, positive energy, people will want to do business with you. If you have a strong, healthy body and a clear mind, you will feel good and be able to accomplish anything you focus on. It is difficult for a tired, burned-out person to be successful. Take responsibility for your physical, emotional, and mental well-being so that you can accomplish your goals. Your energy level is dependent on these three areas, and all three are dependent on each other.

Physical energy is the vital energy of your body. We replenish this energy with food, sleep, rest, exercise, and body movement.

Emotional energy is the basis for your enthusiasm, which will help you sell art. It is the energy that gives you positive feelings for life, love, happiness, and a general feeling of joy to be alive. We can keep our emotional energy strong by learning to handle our negative emotions. Learn to have an APMA—"Anything's Possible" Mental Attitude. Negative emotions deplete emotional energy as well as our physical and mental energies. We need to develop good emotional habits to keep

A feeble body enfeebles the mind.
Jean-Jacques Rousseau

115

If you lose a sale, let it go. Don't let it affect you emotionally. Know that you will close a certain proportion of your sales, but not every one. When you don't sell to someone, let it be an opportunity to learn.

our energy strong. Just one upset while you are driving a car can significantly lower your energy level for the day.

Mental energy determines your creativity, thought patterns and problem-solving and decision-making skills. We keep our mental power alert and efficient by getting enough sleep, meditating, and doing mental and physical exercises.

All of these energy states of being are related. If you have negative emotional energy, then your physical and mental energy will suffer. If you burn up a lot of physical energy, you will have little energy left to be creative. We must work to find and maintain an energy balance among our physical, emotional and mental states. Sensible eating, enough sleep, good daily exercise and adequate rest will help keep our energy levels high. If we don't feel good, we won't be able to sell art the way we would like.

CHAPTER SUMMARY

❏ The closing question asks clients in a direct way to own or invest in the art they are admiring. The answer to a closing question will either seal the agreement or raise an objection.

❏ It is always a good idea to test-close a sale before you go to the close.

❏ A test close can also help you get qualifying information about your client.

❏ Most sales will not take place unless a closing question is asked.

❏ A closing question should slip out naturally. Ask it with a smile when rapport is very high. Remain silent until you hear the answer—no matter how long it takes.

❏ One of the most powerful ways to close a sale is to change the focus of the customer's thinking away from the decision of yes or no, and instead to the ownership and enjoyment of the piece.

❏ When you are closing a sale, remain neutral to the outcome.

❏ Be mindful of your body posture and the position of your hands.

❏ Don't assist people in making a decision they will later regret.

❏ Always Be Closing. Make each step of the selling process a step toward closing the sale.

Chapter 10

Overcoming Objections

Five steps to overcoming objections

Emotion vs reason

"I want to think it over"

Cost concerns

Managing common objections

When dealing with people, let us remember we are not dealing with creatures of logic. We are dealing with creatures of emotion, creatures bristling with prejudices and motivated by pride and vanity. Dale Carnegie

FIVE STEPS TO OVERCOMING OBJECTIONS

Think of objections as concerns, not obstacles.

There is nothing like the frustration that comes when you know that the person wants to own the painting and you don't seem to be able to help them take it. You feel helpless.

Handling objections and closing are closely intertwined in the selling process. They are the reasons people buy art and the reasons they don't. Answering one or more objections is often critical to making a sale. You can answer an objection and close the sale simultaneously.

OBJECTIONS ARE YOUR FRIENDS

It is rare for a person not to object to something during the selling process. That is what selling is all about. Be ready for the objections. When you hear them say, "Great!" then they are fully involved. They really want the artwork. Now your job is to make it possible for them to agree to take it. So listen to their objections. Really listen! Ask them to elaborate if it is not clear. Let your clients know that you are interested in finding out how they think and feel. Repeat the objection back to them so they will know that you have listened to them and understood. Then offer an answer to the objection. Give them an alternative way to look at it. Make a suggestion that will remove the objection. Then close your sale. You both will be glad you did.

Often an objection can be turned into a reason for buying. Think of objections as concerns, not obstacles. If you can emphasize the reason for buying and eliminate the objection, the sale can then happen naturally.

Listen for the reason why a client will buy, and go with that. At the same time, listen for the primary reason why the client may not buy, and avoid or eliminate that. Here are five steps you can take when you hear an objection and are fairly certain that your client really wants to buy.

1. Hear it out. Be sure to listen to your client's complete reason for not going ahead. Remember: The "I want to think it over" ploy is just a tactic we all use to end the conversation and get out of there! Example:

Client: "I want to think it over."

Salesperson: "You want to think it over?"

Client: "Yes."

2. Feed it back. When you let your clients know that you have really listened to them, they will respect you more. The best way to do that is to give their objection back to them in your own words. Example:

Salesperson: "That's a good idea. It's important not to rush into this kind of decision."

Agreeing with your client will help them relax.

3. Question it. At this stage, you are questioning the objection to be sure that you understand what they are saying. They are relinquishing the opportunity to own this artwork. Do they really want to do that? Will they be sorry later? Many pieces of art are originals. There is no other. They must understand that they may not have this opportunity again. Example:

Salesperson: "I'm sure that you have a good reason to want to think this over. You realize that this is an opportunity to own a one-of-a-kind original. Tell me, is it the money involved?"

Client: "Why, yes, I guess it is. I'm concerned about the cost."

4. Answer the question. Here is your opportunity to show the client that it is a good idea to go ahead. Review what has already been established. Use your creativity and resourcefulness to answer the objection. Example:

Salesperson: "We both know that you really love this piece. We know that it will fit perfectly in the spot you have for it. We also know that you can afford it. When you think of the many years you will continue to enjoy this, the amount of money will be well spent. I believe that this piece was meant for you. I have never seen someone so excited about this particular artwork."

5. Go on and close. It is no use answering an objection that may surface if you don't go on and ask for the close of the sale. After you have gone through the above four steps, you must now ask a closing question. Example:

Salesperson: "Shall we go ahead?"

If another objection comes up, then you need to repeat the above process.

Mastery is not something that strikes in an instant, like a thunderbolt, but a gathering power that moves steadily through time, like the weather.
John Champlin Gardner Jr

EMOTION VS REASON

It has been said that first people own, and then they buy. People justify their decision to own with their reasons. People buy art with their emotions.

- ▸ They buy what they like.

- ▸ They buy what inspires them.

- ▸ They buy what moves them.

- ▸ They buy what connects to them.

- ▸ They buy what makes them feel good.

ASKING THE RIGHT QUESTIONS

Often, when clients feel a strong emotional connection to a work, they will want to own it. By asking the right questions, you can help involve your clients emotionally in a work of art. For example, you can ask:

- ▸ Does it excite you?

- ▸ How does it make you feel?

- ▸ What grabs your attention about the work?

- ▸ What excites you most about this piece?

This is much easier than trying to help clients overcome their objections. Objections are often based on reason. Emotions generally win over reason. When you know that your clients are emotionally involved, it is far easier to help them rationalize the decision to own. And, of course, this is done by asking the right questions.

In most cases, people will buy art because of the emotional connection, but they also want to rationalize their decision with reason. So it is important that you, as a salesperson, have a number of good reasons why the person is buying the artwork. For example: "It will really add just the right accent to the lobby of the corporate office." The client needs these reasons to help rationalize spending the money and to keep from having buyer's remorse after the sale has been made. Otherwise, you will be returning the money the next day.

As a salesperson, you need to do your homework. If you are an artist selling your own work, you already know these answers. You need to be familiar with and ready to ask and answer questions on the following topics:

Medium	Style	Technique used
Published articles	Important reviews	Museum shows

You are not beaten until you admit it.
George S Patton Jr

Gallery shows Corporate shows Public art shows

Artist's awards Museum collections Government collections

Other collections, corporate and private

These are the most important facts you need to have available to share with your clients while they are becoming emotionally involved. Have published material—copies of newspaper and magazine reviews, brochures, books and cards—available to hand to your clients when reviewing this information.

EXERCISE

Go over the above list and fill in the information for each artist you represent. If you are representing yourself, go through the list and make note of the most important information for each category. You don't need to tell your clients everything—just enough to help them know that they are getting a work by a recognized or established artist. People want to feel that the artwork they are buying will appreciate in value, even though the chance of ever selling it is small.

CHART

Medium _____

Style _____

Technique used _____

Published articles _____

Important reviews _____

Museum shows _____

Gallery shows _____

Corporate shows _____

Public art shows _____

Artist's awards _____

Museum collections _____

Government collections _____

Other collections, corporate and private _____

"I WANT TO THINK IT OVER"

When the eyes say one thing,
and the tongue another, a
practiced man relies on the
language of the first.
Ralph Waldo Emerson

How do you answer the "I want to think it over" statement? When you hear this, your client is really saying "Goodbye." You know from your own experience that a person doesn't think it over and get back to you. It is estimated that one-half of the people who say this are ready to buy. They just need a nudge. When people are making buying decisions, they get uneasy, tense and afraid that they will make a mistake. For some people, it is a traumatic situation for them to be spending so much money on a nonessential luxury item. You don't really expect them to take some time to think it over with their bank statement and a calculator. At the same time, if you allow them to "get away," you will likely never be so close to having this chance with them again. When the water in the tea kettle is hot, that is the time to make the tea. The next day, the water will be just as cold as it was before you turned on the heat. People are the same way.

Next time you hear this:

Client: "I want to think it over." (The client is really saying, "Goodbye.")

Answer:

Salesperson: "Oh, you want to think it over?" (Smile in agreement.) "That's a good idea. This will be a valuable art purchase for you, and you don't want to rush into it." (I like to emphasize that this purchase will be valuable for the client. Art can add value to a person's life.)

This will help your client mentally relax. As you say this, you may want to be removing the painting from the viewing-room wall and putting it back on the gallery or studio wall. Your clients will assume that you are ending the presentation, and their resistance will drop. They may even feel a little sad that they have not gone ahead and made the purchase. They realize that the artwork they have been admiring and wanting is going back on the wall and will be available for another buyer. They are losing their chance to own that piece. It's not unusual for them to change their mind at this point and decide to take it. If they really wanted the piece, they will feel a loss, especially if they had already imagined themselves owning the piece.

At this point (as you are placing it back in its spot on the wall), ask:

Salesperson: "I'm curious. Obviously you have a good reason to want to think it over. May I ask what it is?"

This is a test close. You must remain perfectly silent, just as you would for a closing question. Or you might say to them:

Salesperson: "I'm sure you have a good reason for wanting to think this over. Is it the money?"

Remain silent, smile, and wait for the answer. In most cases, the person will say:

Client: "Yes, I'm concerned about the cost."

or

Client: "No, it's not the money."

The main reason for a person not to buy is "the money." If the answer is the cost or "the money," immediately go to a series of questions to deal with price concerns. Ask questions like this:

"What do you mean exactly?"

"Why do you say that?"

"Why do you feel that way?"

"Is the price your only concern?"

"Is there something else?"

"How far apart are we?"

These are great questions to ask. Any of the above questions will get the conversation moving again in the direction of closing the sale. Once your client has sufficiently answered the above questions, she will be more open to going ahead. If she is truly in love with the piece, help her own it.

COST CONCERNS

When your client tells you what her concern is, you can decide if you want to continue to sell the piece. The concerns may be well founded—not just normal buyer's reluctance to part with the money. You don't want to sell to someone who truly is going to regret the purchase afterwards. Although this is rare, it has happened to me.

A woman said that she wanted to own one of my watercolor paintings. She came to my studio and we drank a little sherry. She picked out a painting that she really liked, and I made the sale. She wrote me a check for the painting. She was excited about owning this work of art. I knew that when a person has just completed a sale, it is a great time to talk about another purchase. So I showed this person a large woodcut print that I had recently completed. She loved it. So she wrote me a second check for the woodcut print.

The next day I got a call from the woman, and she said that she had overspent her budget. She loved the print but really couldn't afford it. So she brought it back and I gave her the second check back.

If you decide that the client really wants to own the piece and it is just a matter of finding the right terms that will help the person agree to the purchase, go ahead and finish answering the objection by asking another closing question.

If the client answers:

Client: "No, it's not the money."

Ask:

Salesperson: "May I ask what it is?"

Remain silent, smile, and wait for the answer. When the person finally tells you the real concern, hear it out, feed it back, question it, and then satisfy this final condition and close the sale.

It is a good idea to practice these responses with a friend so that you will be ready when the situation arises. There is nothing like the feeling you get when you don't know how to respond. Hopefully, this book will give you the confidence you need to make those sales you have been losing when people say to you, "I want to think it over."

Know and understand your pricing.

PHRASES TO JUSTIFY THE PRICE

One of the most frequent objections people use is, "It costs too much." Or they say, "It is more than I can afford." Many people want to buy a work of art but don't want to spend so much money, or they find it difficult to justify spending so much money on a luxury item. Art, particularly original works by renowned artists, can be expensive. The following are examples of phrases you can use to justify the price.

"Why pay $_____ for a print when, for a few dollars more, you can own an original?"

"A _____ like this is for people who can have whatever they want."

"If you have expensive tastes, you will want to own a _____."

"Isn't it better to spend a little more now on an original _____, instead of a lot more later?"

"This _____ may cost more than a ____, but it's worth much more."

"This original costs so much more than a print by the same artist, but it is the only one there is."

"This _____ is very reasonably priced at $_____."

"If you like, we can send you a monthly statement of just $_____."

"Taking care of the full amount now will save you money."

"Isn't it worth paying the price for something you really want?"

"Why don't you get it? You are worth it."

"You probably thought you couldn't afford an original _____."

"You're paying for the quality, originality, the exclusivity, and of course the name and recognition (or reputation)."

"Why don't you allow yourself a little luxury?"

"Art is a luxury that can be within anyone's reach."

"This _____ is a luxury that is not within everyone's reach."

"It's not as expensive as you may think."

"It's the Rolls Royce of ____."

"It's flagrantly expensive!"

"Don't you deserve the best?"

"Life is worth living well."

MANAGING COMMON OBJECTIONS

Here are some sample dialogues for the really tough, common objections. Remember the five steps to handling objections outlined previously.

- ▸ Hear it out.

- ▸ Feed it back.

- ▸ Question it.

- ▸ Answer the question.

- ▸ Go on and close.

Avoid negatively charged words such as price, cost, buy or sell.

I ONLY BUY OILS—I'M NOT INTERESTED IN WATERCOLORS

Client: "I never buy watercolors."

Salesperson: "May I ask why?"

Client: "Sure, that's easy. Oil is more permanent."

Salesperson: "Did you know that oil paintings crack and peel when they become old, dry and brittle? That is not true of a watercolor. Watercolors, when framed and cared for properly, will last many lifetimes. Look at JMW Turner. Paintings he did 200 years ago are just as fresh as when he painted them. The ancient Egyptians painted on paper, and their pieces are still intact today. These watercolors are painted on the finest cotton rag archival paper. They will last for many, many generations."

Client: "But watercolors are not considered fine art. It's kids' stuff."

Salesperson: "You are right. Watercolor is used in elementary schools to introduce painting to kids, primarily because it dries quickly and uses a water base; much less messy than oil paint. However, did you know that watercolor is a very accepted medium in the art world? The Chinese painters have used ink and watercolor for many centuries. Paul Cezanne's late work was based on his watercolor painting experience. Vincent Van Gogh painted with watercolor. Winslow Homer is more famous for his watercolors than his oils. The Metropolitan Museum of Art in New York City has over 400 of John Singer Sargent's watercolors. In short, watercolor is not just a medium for beginners. It takes great skill to find your way as a painter in watercolor. Because of the medium's spontaneity, many oil painters will tell you

that watercolor is too difficult for them. Now, will you consider owning this watercolor that you have fallen in love with?"

Client: "I didn't know that watercolors were so highly regarded."

Salesperson: "Yes, Nolde, Prendergast, Whistler, Chagall, Picasso, Toulouse-Lautrec, and Andrew Wyeth all painted in watercolor. Can you imagine what those are worth today?"

Client: "Wow. I'm sold on this watercolor. I'm going to get it."

Salesperson: "Congratulations!"

You can use a similar approach for selling prints on paper rather than oil paintings. If you have some knowledge of art history and famous painters, you can use this information to educate your client and sell art.

IT COSTS TOO MUCH

This is probably the most common objection. It is good to have at least two or three ready answers to this objection. Look at the list of phrases given earlier in this chapter to justify price. The following is one of my favorites.

Client: "It costs too much."

Salesperson: "It is too much? You mean that it is more than you would like."

Client: "Yes, it costs more than I can afford."

Salesperson: "May I ask you how much more it is than what you would like it to be?"

Client: "Oh, I don't know. I guess it is about $1000 more than I would like."

I have used the following exercise effectively to close sales. It simply puts the money in perspective to the artwork's value.

Salesperson: "Let's try this. Would you take this calculator?"

(Hand the calculator to your client. Always let the client do the math. It gets her actively involved. If you say something, the client may doubt you; but if the client says it, it is true.)

Salesperson: "Please punch in $1000.

Client: "Okay."

Salesperson: "Now let's assume that you will be enjoying this work of art for the rest of your time on earth. Let's estimate what that might be. Would you say another 30 or 40 years?"

Client:	"That sounds good."
Salesperson:	"Which?"
Client:	"Let's say 30 years."
Salesperson:	"Good. Why don't you divide $1000 by 30. What do you get?"
Client:	"$33.34."
Salesperson:	"Would you say that you will be enjoying this painting for 50 weeks a year?
Client:	"Yes."
Salesperson:	"Good, now please divide the $33.34 by 50. What do you get?
Client:	"66 cents."
Salesperson:	"Let's take it down to the day. What do you get when you divide .66 by 7?
Client:	"About 10 cents."
Salesperson:	"Doesn't that make it sound more manageable? I would imagine that you don't want to give up being able to own and enjoy this great artwork for just 10 cents a day, do you?
Client:	"Well . . . when you put it that way, it doesn't seem so bad."
Salesperson:	"Sometimes we just have to put things in their proper perspective, don't you agree?"
Client:	"I guess so."
Salesperson:	"Shall we go ahead with the paperwork?"
Client:	"Okay."
Salesperson:	"Congratulations!" (Shake the client's hand.)

This technique can be used with the amount more than the client wants to pay and also with the entire purchase price. Either way, it is effective. Notice that the salesperson never uses negatively charged words: pay, buy, sell, cost, price.

IT WON'T FIT THE DÉCOR OF MY HOME

Whatever the décor of the person's home or office, most art will fit in when framed or mounted properly to complement the décor. Suggest this to the client. If the client still hesitates, suggest that you demonstrate how great it will look by actually taking the piece and hanging it in the home or office. Here is another way to handle the objection:

Salesperson: "Art has a unique way of integrating perfectly with the environment in which it is placed. Just think of how wonderful the great abstract painters' works look in the old, traditional exhibition spaces of the New York Metropolitan Museum."

I'VE NEVER HEARD OF THIS ARTIST

Client: "But, I've never heard of him."

Salesperson: "That's exactly why you want to acquire one of his originals today. He is considered an emerging artist. I know of a person who picked up four Andrew Wyeth paintings in the 1950's for $50 each, when no one was paying any attention to him. Can you imagine what those paintings are worth today?

Client: "Wow, I can imagine they are worth millions."

Salesperson: "Exactly. And that is the reason you are attracted to this man's imagery. You have a good eye for art. You can be sure that years from now, these paintings are going to be very valuable. Just because you have never heard of the artist is not a reason to pass up owning a work that you love, don't you agree?"

Client: "Good point."

Salesperson: "Is it yours?"

Client: "Okay, I'll take it."

Salesperson: "Congratulations. You have made an excellent decision!"

I LOVE IT, BUT MY WIFE (HUSBAND, PARTNER) DOESN'T LIKE IT

This is a very common objection. One wants it, but the other doesn't.

Client: "I really like it, but my wife doesn't feel drawn to it."

Salesperson: "That's normal. Art is a very personal experience. It is rare for two people both to be enthusiastic about the same piece. Why don't you each select something that you really like? I can tell you it will be almost impossible to find something that you both love just as much. You might find something that you both like and can live with. But why don't you both get what you really want?"

Don't be put off by objections.

IT'S TOO COLORFUL/STRONG/SUBTLE/DRAMATIC/LARGE/SMALL

There always seems to be something the client doesn't think is right. But you know that he wants to own the piece and will thank you in the end for helping him get it. Whatever the objection, always agree and then show him how to see the very characteristic that he is objecting to in a positive light. For example:

THE OBJECTION:	YOU SAY:
Too colorful	"In your home, it will become a dramatic focal point."
Too strong	"In your office, it will be a symbol of the strength of your business."
Too subtle	"That is exactly what draws you in. It will become a conversation piece."
Too dramatic	"It will add energy to your environment."
Too large	"Live dangerously! People will admire you for your audacity to hang this in your home."
Too small	"With a good-sized frame, it will be a very important piece of art in your collection."

Objections can help you give your clients just what they love. They are just trying to rationalize spending all that money. They want you to tell them that it is all right! No matter what the objection, there is always a good answer. Don't be discouraged when someone gives you an objection. Be appreciative, and then use your creativity to come up with the appropriate answer.

EXERCISE

Write down the objections that you most frequently hear. Then write 10 different answers to each objection. You will then be prepared the next time you hear the objections.

OBJECTION _____

RESPONSES _____

OBJECTION _____

RESPONSES _____

In the middle of difficulty lies opportunity.
Albert Einstein

CHAPTER SUMMARY

❑ Usually, you will need to work through at least one objection before closing a sale. When you hear an objection, you know you are almost there.

❑ It is possible to answer an objection and close the sale simultaneously.

❑ Here are the five steps to overcoming an objection:

Hear it out.

Feed it back.

Question it.

Answer the question.

Go on and close.

❑ If you want to sell more art, you need to practice overcoming objections. Question and respond to objections until the sale is complete.

❑ Practice some of the phrases in this chapter with a friend until you feel comfortable using them.

❑ Write out scripts relative to objections that you frequently hear. Then you will be ready the next time you hear one.

❑ Don't be put off by objections.

Chapter 11
After the Sale

Referrals

Thank-you notes

Why not go out on a limb? Isn't that where the fruit is? Frank Skully

REFERRALS

One of the best ways to expand your client base is to ask for referrals when you sell a piece to a new client. The best time to do that is right after the sale has been made. It is the time when you and your new client feel relieved that the "business" of purchasing the art is finished and the enjoyment of the piece begins. The client feels lucky to own the work. Most likely your rapport with the client will be very high, and she will be happy to give you a referral.

ASK KINDLY AND WITH A SMILE

Salesperson:	"By the way, Judy, do you know anyone from your country club who might also like to own a work by (name the artist)?"

You know what to do. Yes, you wait for an answer. Don't interrupt. Give your client some time to think about your question. Asking for a person in a specific category—the country club—makes your question easier to answer. Use the appropriate categories for your client: your office, your department, your garden club, your health club, your bridge club, your book club, your tennis club, etc.

If she gives you a name, thank her. Then ask if she would mind recommending you to her friend. Find out when they will see each other the next time and then follow up with her with a phone call after that time. If she is very enthusiastic, she may even agree to call the friend right then and there on the spot. That is the best you can do. Then make an appointment with the referred individual. Follow up with a thank-you note whether a sale occurs or not.

The following is a sample dialogue:

Salesperson:	"You are now the proud owner of an original Dvorák. How does it feel?"
Client:	"Well, it feels great! I can't wait to get it home and hang it. I know just where it will go."
Salesperson:	"I'm so glad that you are happy with your painting. Is there anyone from your tennis club who might be interested in owning a work of art? Or can you think of someone who would appreciate being on my mailing list?"
Client:	"Why, yes, I can think of two different individuals right now. I would be happy to refer them to you."
Salesperson:	"You don't suppose that I could get you to call them to introduce me?"
Client:	"Why not?"
Salesperson:	"Do you think that they would be home right now?"
Client:	"Let's try."

If you think that the above conversation is unrealistic, it isn't. The client is very pleased. She is grateful for the attention and care that she has received. She is happy to give you a couple of referrals. She is proud of her purchase and wants her friends to know her good taste and judgment in buying this art. She likes you and wants to introduce her friends.

If it turns out that you are the person making the call, you will introduce yourself with the name of the client who referred you. Tell the story of her happy purchase and then ask for an appointment. If you don't get an appointment, ask if the person would like to be on your mailing list for future shows and exhibitions. The next time you have an exhibition, give him a personal telephone invitation.

I was living in the San Francisco Bay Area. I took a trip to Los Angeles and showed my work to an art gallery there. The owner didn't say no, but she didn't say yes, either. A year later, I visited the gallery again and showed the owner more work. She said that she knew "someone" she thought might be interested in seeing my work, someone she thought would be interested in working with me. She was vague about the connection. She suggested that I send her some slides. I prepared the slides, a cover sheet and cover letter and sent them off, but I heard nothing. A year after that, I traveled to Los Angeles and dropped in again at the same gallery. The slides I had sent were sitting on top of a file cabinet. She said the same thing again. She knew someone, etc. I said, "Would you call them for me?" She said she would. Then I said, "Would you call them for me now, while I am here?" She walked to the phone, called, and made an appointment for me the following day. It was an art poster publisher, and yes, they liked the work. That referral turned into a published poster and a one-man show at a very well-known Southern California art museum. It would never have happened if I hadn't asked for the referral and then asked for some action on the spot.

THANK-YOU NOTES

If you make a sale to one of the people your client referred, send a thank-you note to your client.

"Thank you so much for referring me to Mr. Artcollector. He acquired a painting from me for his office this week. Enclosed is a token of my appreciation."

Include a small print, a beautiful poster or even a small painting—something you know your client will appreciate and value. You may also suggest that the next time she selects a painting from you, she will get a 10% discount as a way of saying "thank you" for the referrals. Give her an added incentive to keep in touch and to buy more art from you.

There is so much to do to be successful in this business. It is sometimes very hard to do everything you know you "should" do. But there is one thing that is a must. Follow up with a thank-you note on a sale, a client meeting, a gallery appointment, a referral, or any situation where someone gave you time, energy or money.

THREE PRINCIPLES OF A GOOD THANK-YOU NOTE

▸ Say what it is for.

▸ State how it has benefited you.

▸ Offer something in return.

A thank-you note is a brief, appropriate and sincere expression of appreciation. That is the primary intention. If possible, try to offer something in return.

A thank-you note adds heart to the cold world of business. And, since a lot of art comes from the heart, a sincere note of appreciation is never out of place. Gallery owners, businesspeople, artists, and everyone else will remember thank-you notes and the people who sent them.

▸ If you visit a gallery for the purpose of seeking representation, send the gallery and the person you spoke with a thank-you note.

▸ If a client comes into your gallery and is sincerely interested in owning a work of art, send a thank-you note.

▸ If you write a gallery for information on how to submit work and the gallery responds by sending you application materials and guidelines, send a thank-you note.

By nature, a thank-you note is brief. It is not a letter.

EXAMPLES OF THANK-YOU NOTES

From a salesperson: "The gallery staff and I want to tell you how much we have appreciated working with your company these past few weeks. Thank you for your collaboration and confidence. Please accept this small token of our appreciation."

From an artist: "Thank you for taking the time to look at my portfolio. Your insightful comments and kind referral have been very helpful. Please come visit the studio and pick out a gift—a small print for your office."

From a gallery: "You will be pleased to know that your April art sales broke all our gallery records. It is wonderful to have you as part of our team. Please accept the enclosed print as a token of my appreciation."

From a client: "Just a note to tell you how much we enjoyed working with your staff person, Judy Seller. She was so attentive to our needs, and we are delighted with our new art piece. Please visit for a glass of wine and see how beautiful our _____ looks in our living room."

From an art rep: "I want to thank you for your recent acquisition for your outstanding art collection. Your enthusiasm for art is infectious. We at _____ Gallery want you to know that you may have a 10% discount on any art you obtain from our gallery in the future."

As you read the above thank-you notes, you can see how each reflects my three principles for a good thank-you note.

INDIVIDUALIZED THANK-YOU STATIONARY

When I send a thank-you note, I either send some small, original work of art or a nice card from my collection. Use your creative thinking to find a unique way to send a note of thanks.

Only by giving are you able to receive more than you already have.
Jim Rohn

139

CHAPTER SUMMARY

❑ The best time to ask for a referral is right after a sale has taken place.

❑ Ask the person giving the referral if she will make the call for you.

❑ If you are calling the referral, introduce yourself with the name of the person who referred you. Mention that the person has just become the proud owner of an original work of art.

❑ When you make a sale to a referred client, send a thank-you note and a gift to the person who referred you.

❑ Keep thank-you notes brief and to the point.

❑ Make thank-you notes upbeat and personal in tone.

❑ Use the person's name on a thank-you note.

Chapter 12
Sale Venues

Art fairs

Open studios

The viewing room

Networking

Gallery floor selling

International sales

There is only one thing to be said at an opening: You say congratulations.
Louise Bourgeois

ART FAIRS

People who attend outdoor art fairs think that they are not paying gallery prices. However, if you also sell in a gallery, you will have to sell your work for comparable prices at the art fair or in your studio. You can't undersell your gallery if you want to keep exhibiting your work with the gallery.

COMMITMENT AND PREPARATION

Art fairs are a great place to sell your art. I know artists who support themselves very well by "doing" art fairs.

Start out doing local art fairs (within 100 miles of your home). It will take you three to four fairs before you begin to get your presentation and sales techniques down. Don't give up if you have a poor weekend. Art fairs require a lot of preparation and a real commitment of time during the fair, as well as a lot of creative thinking. Plan, plan, plan and plan some more. There is packing and preparation time, travel time, set-up time, chatting-with-the-public time, selling time, take-down time. I have a lot of respect for artists who sell at art fairs, and I try to support them by purchasing something when I attend. I used to do art fairs, but I just don't have the time anymore. Don't begin to sell at art fairs unless you intend to do a lot of them.

PRACTICE YOUR SELLING SKILLS

Art fairs are an excellent venue to practice your selling skills. You will have literally hundreds of opportunities to practice selling. If you really want to learn to sell your work, I recommend doing 25-50 art fairs. At the end of that time, you will have developed a personal selling style that relates perfectly to the work you produce.

You must be willing to be with the public—all kinds of people. You will hear all types of comments about your work. Sometimes people are unkind, outspoken, or rude. Others will be enthusiastic, supportive, or appreciative. Treat everyone with respect. Don't judge people by how they look or what they say. Art fairs are a real lesson in human nature. You will be surprised that people whom you would never expect to buy from you end up doing just that. You will meet a lot of people, some of whom will become your loyal collectors. Make everyone feel important—they are.

Develop your easy conversation skills and questions. Learn how to pull people into your 10x10 foot gallery space. Have a painting, a print, or a poster that is an eye-catcher. I used to use my "King of Beasts" poster to attract people's attention. If you want to see it, look at my web site www.youcreate.com. You will see why it grabbed people's attention. Remember that you are competing with all the other booths. Ask yourself why people will want to come and look at your art.

LOOK GOOD AND SMILE A LOT

Wear clean and neat clothes. Kid around with people. Keep it light and fun. If people like you, they will buy from you.

NICE-LOOKING BOOTH

Your booth should look like a small gallery. Have inexpensive merchandise—prints or posters—available. You can have bargain bins for people to browse through as a way of getting people involved.

ASSISTANCE

Be sure to have someone available to relieve you periodically. (Sometimes the presenters supply this person to rotate through the booths). You need to take breaks. Don't eat in your booth; have someone else watch your booth while you eat lunch. The booth is for selling and promotion, and that is all. Think of a booth at an art fair as a mini open studio.

Pick the best art fairs in your area. If they are juried, send in your applications. If you get accepted to show and do well, there is a good chance you will be invited back the next year. Some artists travel around the country in their vans all summer doing art fairs. They produce work during the fall, winter and spring for the next summer's art fairs.

TIPS

- Make your booth look like a small gallery.
- Have some inexpensive pieces, perhaps a bargain bin.
- Have plenty of business cards to hand out.
- Ask a visitor, "What kind of artwork do you collect?"
- Never sit in your booth.
- Never read a book in your booth.
- Wear a name tag.

RESOURCES

Sunshine Artist - This magazine reviews art fairs all around the country. The September issue lists the Top 100 in a variety of categories, including fine art venues. www.sunshineartist.com

Art Fair Sourcebook - Listings include 600+ USA national art shows and craft fairs, many juried, with reviews and critiques. www.artfairsourcebook.com

Local arts councils will have information about art-related events in their vicinity.

It is good to have a wide price range, between $25 and $10,000. Most sales will most likely be under $1,000. You will also have to be set up to accept credit cards.

OPEN STUDIOS

One of the least expensive and best ways for an artist to sell artwork is during an open studio. I know a number of artists who support themselves for the entire year on just one open studio event. If you do it right, and you have high-quality art to sell, you will do very well.

The best place to have an open studio is in or near a metropolitan area. The San Francisco Bay Area, where I have my studio, has many open-studio events. Each area has an organized open-studio art tour that is sponsored by an open-studio art organization and takes place over three to four weekends. The art tour organizer has a mailing list of interested buyers, collected over the years, and they do a huge mailing to publicize the event with a brochure and map to direct buyers to individual art studios. They also publicize the event in the local newspaper. For a fee, an artist can be included and have her studio noted on the map. Artists who are serious and ready to sell their work know that the fee is well worth it.

I recently had an open studio. My studio is part of a community of artists' studios at an art center. People who came to see a specific artist walked into my studio as well. Most of these people were strangers to me and my studio.

WHAT TO SAY

When people enter an artist's studio for the first time, they are, understandably, a little timid and guarded. After all, this is the artist's private space. Your job is to make them feel comfortable and welcome. A generous smile and friendly greeting goes a long way. Classical music playing softly will also help people relax, putting them in a more right-brain mind.

Salesperson: "Welcome to my studio. I'm Robert" (smiling warmly).

Or, if you are a representative for the artist or helping out at the open studio event, say:

Salesperson: "Welcome to (Mr. Artist's) studio. I'm Sally and I am helping first name today."

If it seems appropriate, shake hands. Then you might add:

Salesperson: "Is this your first visit to (my or Mr. Artist's) studio?"

If it is the first time, you can ask:

Salesperson: "Would you like to look around on your own, or would you like a tour?"

Remember that your job is to ask questions and develop rapport. If they prefer to explore on their own, after a few minutes, you can say:

Salesperson: "What brings you to the art center today?"

Whatever they say, you can just reply, "Oh?" The "Oh?" question encourages people to continue to share their thoughts and ask questions.

The idea is to gain rapport and slow people down so that they can actually see something in your space. I have learned that unless you do that, many people will come in, make a large sweep of the space quickly, taking in everything at once and labeling it all with their left brains as "artwork," then walk out. It is also helpful if you have some very unique piece prominently displayed that will immediately grab their attention. If you can get people to stop and really look at something, then they are more likely to find something that they want to own.

At an open studio event, I like to have a variety of work for sale at different price levels. I will have large and small original paintings and prints. I will also have posters and cards that sell between $3-20. People like to come to an artist's studio because they feel they have a wider selection than at an art gallery. They also think that they may be able to get a bargain.

If someone picks up something and looks at it, that is a sure signal that he is thinking about buying it. Your job, then, is to ask the right questions so that he will.

Salesperson: "Are you considering that one?" (This is a very low-key test close.)

Client: "Why, yes I am."

At that point, they may say,

Client: "Yes, I'm going to take it."

Or if they don't say so, you can ask:

Salesperson: "Are you going to take it with you?" (Use a gentle voice and friendly smile.)

Or ask any of the 10 closes in Chapter 9.

Wait silently for their answer.

PUBLICITY

Send out your own open-studio announcements two to three weeks before the event. I have a list of names and addresses on the computer. My office assistant prints out address labels. It is fairly easy to get a postcard printed up with a color image and your open-studio announcement on the other side. Use an image of a work that is for sale. I have used www.modernpostcard.com many times and find that they give good, timely service and that their prices are very competitive. If you can't afford a printer for color postcards, improvise on your computer and use a copy service to print your cards. Use your creativity to find the least expensive way to do an invitation that will be eye-catching.

Clutter will distract buyers from seeing the work.

At a gallery opening some years ago, a gentleman showed me a book he was keeping that contained every show invitation and press story about my work.

YOUR MAILING LIST

Keep all your friends, relatives, past clients, referral clients, and interested people in one mailing-list file, which will include a physical address, e-mail and phone number. Include local newspaper reviewers, local museum curators, and your local TV station on your list. Keep these files current.

When you send a mailer through the Postal Service, put the words "Return Service Requested" at the bottom of the address block. If it is returned, the Post Office will give you the new address. I also print on the announcement in very small print just under the space for the label, "Please check your address label and call, write, or e-mail with any corrections."

When people attend your open studio, have them print their name and address information in the guest book. Have them note if they want to be notified about future open studios and gallery exhibitions. If they don't want to be notified, respect their wishes and save the postage.

Sending e-mail notifications is much more cost-efficient but may not be as effective. A well designed invitation will often be saved and collected by a client or collector.

PREPARING YOUR STUDIO SPACE

Create a warm and friendly atmosphere in your studio.

▸ Clean up your studio.

▸ Sweep and mop the floor.

▸ Put away as much clutter as possible. Many people get upset around dirt and clutter. If your studio is not inviting, some people won't want to stay very long. Since it is your studio, there is a certain amount of clutter that may have to remain, but do your best to put things away, hang up aprons and throw out old paper coffee cups and last night's pizza box. Tidy up your space and display your work in a tasteful way. If your studio has useable outside space, you may want to put up some portable walls or tables outdoors. This will expand your display options. Have a small desk and chair ready as a place to handle sales.

▸ If you are serving food and beverages, have them on a separate table away from the art. A good food aroma can add to the ambiance of the space.

▸ Be mindful of the temperature. Keep your studio warm enough so that people will be comfortable and will want to stay to look at your art. Many studios are cool or cold. Buy a portable heater if you don't have good heating. People won't want to stay if their feet and hands are cold.

▸ Have appropriate music playing. Choose carefully what you play, and keep the volume low. Turn off the music if it becomes too hard to hold a conversation.

▶ Have your work well lit. Make sure that people can see what you are selling in the best light. You most likely won't have a viewing room, but you can improvise. I have a large painting easel in my studio that I use during my open-studio events as a viewing place. I have a moveable desk lamp attached to the easel, and I can place a painting on the easel and light it from above with the desk lamp.

Before I had my own studio space, I used to have open studios in my home. We carried the furniture out of the living room and put it on the back patio; the living room became the art gallery. Artworks were displayed on the walls and tables. The dining space was used to serve food and beverages. Since it was always December, we served warm, spiced red wine and cheese, ham and crackers, which added a pleasant aroma to the environment.

If you don't have a studio and want to organize a kind of open-studio event, you can ask someone—a friend or relative—to rent you a space for this kind of event. You can even offer to barter for the space with some of your artwork. Hold an event at a friend's house, a friend who loves art and has a great space in which to display it.

ASSISTANCE

You will need to get some help during your open-studio hours. Either hire a professional to come and work with you, or, if you don't want to pay another person, ask a friend or relative to assist you. You need at least one other person to help you manage the sales. Artists who already have art representatives working with them may want to have the representatives present during the event. Whoever helps you, be sure that he is aware of your pricing and discount policies. If the person has never sold art before, I suggest you go over some of the material in this book together so that both of you are knowledgeable about selling art.

SUPPORTING MATERIAL

During the open studio, have available next to your guest book your business card, brochures featuring you and your work, and any postcards or posters that you have to promote your work. People like to take away something to remind them of you and your artwork. Your brochure needs to have a list of the collections that own your work, a list of your one-person or group shows and exhibitions you've been part of, and your gallery representation (if you have it).

BARGAIN TABLE

A couple of years ago, I tried the idea of putting out a pile of small demonstration watercolors—6x9″—that I had done in the many watercolor classes I teach. I packaged each in a clear plastic bag and put out a sign that said, "Anything in this pile - $5." For $50, a person could walk away with 10 pieces. They sold so fast, I am thinking of raising the price to $10 next time. One woman bought 18. Think about what you might put on your "bargain" table.

GIVE SOMETHING AWAY

When I have an open studio, besides giving away my promotional material, I always like to have an art piece of some kind to give away to the people who take the trouble to come. Even if they don't buy, I offer them a black and white poster to take home with them. I think that it is a good practice to say thank you for coming, and a way to remember me—especially if they hang it in their house.

RED DOTS

Red dots next to an artwork on display typically mean "sold." If you can do some pre-sales and have red dots on some of your pieces, it will entice visitors to take action. Not only do red dots evoke urgency, but they help people feel that they are making a good choice; after all, someone else bought this artist's work.

TIPS

- Include good directions to your studio on the invitation and large signs leading to the entrance on the days of the event.

- Clean your space and put away as much clutter as you can.

- Some fine rugs on the floor will make your studio look prosperous. Borrow them for the day, if necessary.

- Have something interesting in your studio to keep children occupied, such as a fascinating book or a puzzle.

- Fresh flowers can add atmosphere and a touch of fragrance.

- Make sure that all your work is priced.

- Have bubble wrap and tape handy for carry-out framed works or sculpture.

- Smile a lot.

Many art galleries have a special room called a "viewing room." It is a quiet, private space with three or four places to sit and an easel to hold a painting with focused lighting directed toward the easel. These rooms are sometimes also called "dimmer rooms" because they are equipped with a dimmer switch. You can control the lighting so that the client can see the painting in different lighting. This viewing room is also sometimes called a "closing room" because many sales are closed in this intimate environment. If you are working in a gallery that has a viewing room, you will be expected to use this space.

When clients have indicated an interest in a particular piece, you have qualified the clients, and you are reasonably sure that they are able to pay for it, take the artwork off the gallery wall and carry it to the viewing room. The clients will object, as they always do, but they will follow you to the viewing room.

Salesperson: "Please follow me; I want you to see this with better lighting."

Client: "Oh, don't bother; we were just looking."

Salesperson: "I know you are just looking, but I want you to just look at this!"

Be creative; find the right playful words that will carry the conversation to the viewing room. Smile and enthusiastically say:

Salesperson: "Just look at this! I want you to see what happens to the light in the sky. Have a seat."

The couch or chairs in the viewing room are usually very comfortable. Once your clients sit down, they will want to stay for a while. An art gallery with a viewing room will frequently offer the client something to drink or some kind of treat.

Here are some other examples of what you can say:

Salesperson: "In the gallery, the painting has to compete with all the other works. Here you can enjoy it without any distraction."

Salesperson: "In here, you can see it more like it will appear in your home."

The viewing room is a great place to ask some more of the connecting questions. (See Chapter 8.)

EXERCISE

If you work in an art gallery, practice taking the client to the viewing room, with one of your fellow sales representatives playing the part of the client. Actually take a painting off the wall and role-play with your partner. Then continue the conversation in the viewing room. Use the dimmer switch and ask questions until your partner agrees to buy the work. An exercise like this will give you the confidence you need to use the viewing room with an actual client.

THE VIEWING ROOM

A private viewing space with good lighting to view artwork will add to your success in closing sales. The viewing room, together with connecting questions, will help your clients decide to "own" the art. Use the viewing room to test-close and close your sales.

149

NETWORKING

It takes 20 years to build a
reputation and five minutes to
lose it.
Warren Buffett

Get comfortable navigating in the art world. Although there are some real
deadbeats, I hope you will discover, as I have, that the art world is generally a
friendly place. Most people are helpful and have a good disposition. Always be
respectful. Art gallery owners get tired of people who walk into their galleries
without an appointment and ask for representation. Most have not even researched
the gallery and don't know what it sells.

ART OPENINGS

A good place to network is at art gallery "openings." Circulate and meet people who
look interesting to you. Always make a point to meet the artists and say something
original about your assessment of the work. Let them know that you have really
looked at it. Many people go to art openings just for the party—to drink the wine,
eat the food and meet the people. Make the people more important to you than the
refreshments. Always be at your best. The best publicity you can get is by word of
mouth. Your reputation will follow you.

BE PREPARED

Be prepared to talk about yourself. What do you say when someone asks:

> "What do you do?"

> "What kind of painting do you do?"

> "What medium do you work in?"

> "What kind of art do you make?"

All of these questions require a prepared short and long answer. The short answer
is the one you have ready for those who are obviously in a hurry at the art opening
and want to go on to meet the next person. The long answer is for the people who
really want to get to know you and are interested in what you do. A very good
short answer makes people want to learn more. The idea is to make a favorable and
memorable impression with everyone you meet.

Here is an example of how I might answer the question, "What kind of art do
you make?" when it is asked by another artist or guest. I might answer: "I create
paintings in watercolor and oil in a very personal way. What kind of artist are you,
Don?" That answer gives him enough information to know what medium I use and
that I am not just another of the many thousands of watercolor painters. It doesn't
give any details. If he wants to know more, he might say, "What do you mean by
'a personal way'?" And that would be a lead into a longer, more detailed answer.
You also need to follow up to let him know that you are interested in what he does.
Now you are on the way to building some rapport and connection.

When you are in a social situation, if someone asks about you after you answer, don't forget to ask him about himself with the same amount of interest. Some artists have sizeable egos and care little about what someone else is doing. Only when they sense that there may be a personal gain in knowing you will they really become interested.

People in the art business can be very impatient for success. If you have made the commitment to be successful no matter how long it takes, it will help you be patient.

Most people you meet can assist you in some way. It is a two-way street: You can assist most people you meet in some way. Look for ways to help others, and they will try to help you.

Here is an example of a conversation I had with a businessman standing in line, waiting to board an airplane. He said to me, "What do you do?" I answered, "I am an artist; I paint watercolors in a very personal way. Do you collect art?" As it turned out, he said, "Why, yes I do. In fact, I have a collection of watercolor paintings." Again, there is the power of asking questions.

TIPS

- ☞ If you want to be successful at networking, learn to be interested in people and find out how you can help them.

- ☞ Prepare a short and a long answer to the question, "What do you do?"

- ☞ Always follow up your answer with a question.

- ☞ Follow up with the people you have met.

Be interested and you will be interesting.

GALLERY FLOOR SELLING

THE GREETING

Smile! It is important to remember this. A smile is the best icebreaker. Be friendly and kind. Be warm-hearted and sincere.

▸ Be yourself. Be genuinely interested in each person you talk to.

▸ Try to see people with the letters MMFI—Make Me Feel Important—on their foreheads.

▸ Treat everyone as a potential buyer. Don't judge them by how they are dressed.

▸ Treat everyone with courtesy and respect. Even if they say they are there only to look, there is a good possibility that they will go home with a work of art if you ask them the right questions.

▸ Stay focused on the situation. Don't allow interruptions from people or your cell phone while you are with a client.

▸ Be alert to what your client is doing and saying.

When engaging a gallery visitor, you want to find out as much as you can about the person to qualify her as a potential client. The following questions will help you do that:

Salesperson: "Do you collect art?"

Salesperson: "Have you bought art before?"

If so, ask:

Salesperson: "What kind of art do you own?" (Paintings, drawings, prints, sculpture, posters, old, contemporary, etc)

If not, ask:

Salesperson: "Do you think you are ready to begin?"

Salesperson: "If you knew more about art, do you think you would be interested in owning some special works?"

Do not ask a gallery visitor—a potential client—"dead end" questions such as, "Where are you from?" "Do you know so-and-so?" Keep your questions on the subject of the artwork and how it relates to the client.

DON'T SAY

May I help you? Are you an artist? Do you live in _____(this city)? Are you from out of town? Are you looking for something in particular? Do you have any questions? Would you like to buy something? These can be worn-out questions that will more likely than not annoy the gallery visitor. Try to be original and creative.

DO SAY

Salesperson:	"Hi, welcome!" (Smile!)
Salesperson:	"Welcome to the gallery!" (Smile!)
Salesperson:	"Feel free to enjoy the work as long as you like."
Salesperson:	"Is this your first time in the_____ Gallery?"
Client:	"Why, yes!"
Salesperson:	"My name is _____ _____ (first and last name).
Client:	"My name is Judy Buyer."
Salesperson:	"Is it all right if I call you Judy?" (Judy nods.)
Salesperson:	"And you may call me _____. Let me explain how the gallery is laid out, Judy. Then I will leave you alone so that you can enjoy the works."

If this is her first time in the gallery, simply explain how the gallery is laid out, how the work is displayed, and where she can find everything, including the restrooms, to make her feel comfortable. Use the person's name while you are talking. This will help you establish good rapport right from the beginning.

THEN SAY:

Salesperson:	"Enjoy the work. I'll check back with you later."
Client:	"Oh, that won't be necessary."
Salesperson:	"No problem. I'll check back with you. A lot of people come in just to look and leave with a painting they can't part with." (smile)

If she has visited the gallery before:

Client:	"Why, yes, I have been here before."
Salesperson:	"Then I will assume you know how the gallery is laid out. Is there a particular artist that you are looking for?"
Client:	"Yes, I came to see _____'s work.
Salesperson:	"Let me show you where her work is located."

Then help her to that particular artist's grouping.

If she says no and that she just wants to look around:

Salesperson: "Then I will leave you alone so that you can enjoy the art. If you have a question or would just like to chat about some particular piece, I will be here."

Be careful to keep the conversation on the artwork.

Salesperson: "If you think you might be interested in taking something home with you, please let me know so that I can assist you."

Always invite your clients to take pleasure in and enjoy the artwork displayed. Remember that your tone of voice is very important. It breaks the ice and lets a stranger off the street know that you are open, friendly, and easy to talk to. Suggest the possibility of owning a work of art. Don't be pushy or get in the way of their viewing pleasure. There is no need to volunteer more information than what they want to know. When you are asked a question, answer the question and follow up with a question—after every explanation, ask a question. Take charge and lead the way.

AFTER THE GREETING

Here are some phrases you might use after visitors have had a chance to look around:

Salesperson: "Did you come in to see a particular artist?"

"Do we have you on our mailing list?"

"Have you been in the gallery before?"

"Did you see anything that you would like to take home with you?"

Client: "Yes, of course, but I can't afford to buy any art right now."

Salesperson: "I understand." (Smile.) "But did you see a particular painting that really spoke to you?"

A question like this can open up a serious conversation about a particular piece. If she is willing to show you the piece she is really attracted to, then this will allow you to begin a series of connection questions. (See Chapter 8.)

Always stand and look people in the eye when you speak to them. Never sit while there are people in the gallery. This makes you look uninterested and unavailable.

CO-OP GALLERIES

If it is a co-op gallery, you might explain that the works presented on walls are works by all the members of the co-op. Each member of the co-op is responsible for the management and a percentage of the gallery expenses, and each member must

Remember, after every explanation, ask a question.

take turns working as the gallery representative during business hours. Mention that you are one of the artists. Give your name. Use the same dialogues outlined in the previous "The Greeting" section. But when you introduce yourself, say:

Salesperson: "I am one of the artists exhibiting in this gallery. My name is (first and last name)."

This can be an opening for the visitor to ask:

Client: "Oh, is that right? May I see some of your work?"

It is really a privilege for the gallery visitor to meet one of the exhibiting artists. This could open the way for a sale of one of your paintings.

You can also explain that since this is a co-op gallery, when a painting is priced, there is not the same large markup as in most retail art galleries. Explain that for this reason, the client can own an original painting for around half of what it would cost in a commercial retail gallery. This is an added incentive for a client to buy from a co-op gallery. It is not necessary to tell the gallery visitor what the actual breakdown percentages are.

SPONTANEOUS SALES

There are many situations when sales can take place unexpectedly and spontaneously. Once you get used to the idea that you are able to make sales, you will find that you can make sales in many unusual circumstances. I am always looking for opportunities to sell.

One summer I was returning to California on a flight from Greece. I met a pathologist on the plane who had also been touring in Greece. We stood at the end of the seat sections as we were flying over the Atlantic Ocean at 35,000 feet. I told him I was an artist and showed him some watercolor paintings of Greece in my sketch book. One horizontal, two-page panoramic painting of Santorini caught his eye, and I could tell that he was interested in the possibility of owning it. He was a little concerned about the painting being divided in half at the sketch book's binding. I assured him that when framed, it would look great. The painting was a fair amount of money, and I was not able to close the sale. I did follow up when I got back. I was living in the San Francisco Bay Area and he was living in the Los Angeles area. I called to tell him that I had to come to Los Angeles on a business trip, which was true, and that I would be happy to frame and deliver the painting to him. We agreed on a framed price, and I closed the sale over the phone. Not only did I make the sale, but he treated me to a nice dinner when I was in Los Angeles.

Everyone you meet can become a client. or knows someone who could be.

INTERNATIONAL SALES

Don't limit yourself to local clients. Do some traveling if you can.

Artists and gallery owners need to look beyond the local art scene. In many parts of the world, art and artists are more highly regarded by the general populace than they are in the US. Don't limit yourself to local clients. Do some traveling if you can. Make some connections in other countries. Bring examples of the art that you sell on a CD or iPod. When you introduce your artwork elsewhere, you become more than just a local artist or art dealer. Think Tokyo and Toledo. Think Venice, Italy and Venice, California.

When I was younger, I traveled in Asia and decided to live in Japan for six months—the full extent of time I had on my visa. I contacted a gallery in Tokyo and showed them some samples of my work. They agreed to give me a show while I was living in Tokyo. When I left Japan, I traveled to Russia, Eastern Europe, Venice, Rome, Munich, Paris and New York with the money that I received from the works sold at that show.

One way I have found to show my art is to put a sampling of my paintings on my iPod. I can hand my iPod to a potential buyer or gallery owner anywhere in the USA or abroad, and they can watch a high-quality presentation in just minutes. Remember that equipment like this can be a tax deduction. It is an important part of your marketing expenses.

IPODS

Some years ago, I was introduced to Tatsuo Saito, a Japanese sumi painter, while he was traveling in the USA. He had made it a point to travel extensively in the USA over the years. In spite of his very limited English (he always carried a translation dictionary with him), he had a number of shows that were arranged for him at prestigious universities, catalogues were published of his works, and he made many friends and connections. This foreign exposure was very helpful to his reputation as a successful artist at home in Tokyo. He always carried a brush, some paper and black ink. He told me that he had made his living and supported his wife and children, all his life with only his brush.

CHAPTER SUMMARY

❏ Art fairs are an excellent venue to practice your selling skills.

❏ Learn and develop good conversation skills that will include the questions you must ask.

❏ Open studios can be a very lucrative venue for an individual artist to sell in once or twice a year.

❏ The idea is to gain rapport and slow people down so that they can actually see something in your space.

❏ Part of your organization must be compiling and updating your mailing list.

❏ Have a special quiet, private space with three or four places to sit and an easel to hold a painting with focused lighting directed toward the easel.

❏ The art world is generally a friendly place. Most people want to be helpful, and they have a good disposition.

❏ Gallery openings are a good place to network with others.

❏ When you are selling on a gallery floor, be friendly, kind, warm-hearted, sincere and genuinely interested in each person that you talk to.

❏ Always be open to sales opportunities anywhere you happen to be in the world.

Chapter 13
Setting Sales Goals

Have a successful attitude

Write down your goals

If one thing matters, everything matters. Wolfgang Tillmans

HAVE A SUCCESSFUL ATTITUDE

To be a successful artist requires good planning.

Your future success is determined by your attitude at this moment. Goals can help you maintain an attitude of success. Goals are like magnets that pull you toward your desired outcomes. More important than learning how to achieve what you want is discovering what and why you want it. Once you know that, you can write down your goals. When your goals are written down, preferably in your handwriting and in the present tense, they become imbedded in your mind. Then they have permission to manifest.

ORGANIZE YOUR TIME AS AN ARTIST

If you are an artist setting goals, consider your time as one of your most valuable commodities. You may feel that all you want to do is to create art—paint, sculpt, make ceramics, draw, plan new works or new installations. Artists, however, must be the creative and production department, the salesperson, the public relations, publicity, advertising staff all at once. If you truly want to succeed at selling art—the business of art—you must be very well organized.

GETTING ORGANIZED

You must manage your time and activities to your advantage. For example, you might set aside two hours each day to conduct your business. During that time, you will decide which shows to enter, return calls to potential clients, work on your bio and artist's statement, update your web site, apply for grants, and do anything else that will help further your career as an artist. Perhaps you think that two hours a day is too disruptive to your creative work time. You may want to set aside one full day each week to conduct your business. Or you may need to block out large chunks of time for creating—say one or two months—and then devote one or two weeks to your sales and marketing business. To make the most efficient use of your time, plan how you will divide up your time, and stick to your plan.

A good habit is to spend 15 minutes each morning planning how you are going to spend your day. Some people prefer to spend half an hour in the evening to plan the next day. Then, when you get up in the morning, you know exactly what your plan is for the day.

Look at your calendar and see where you can group activities (such as running multipurpose errands). Always check for time wasters. Turn them into time savers.

Another good habit is to spend some time on Sunday evening or Monday morning going over the week ahead and setting your goals for the coming week. Write down your tasks and prioritize them in order of importance. Then work on the top priorities first.

Watch out for the proverbial time wasters—television, parties, entertainment, procrastination, food. Keep your body healthy and your mind sharp by exercising every day, eating right and getting enough sleep. Days go by quickly; use your time wisely.

Shoot for the moon. Even if you miss, you will land among the stars.
Les Brown

Begin writing your general goals down now. Ask yourself what kind of life you want, what kind of success you want to experience. Then begin writing. Don't wait. Write as many goals as you can. Write as fast as you can. Write them in the first-person present tense. It is okay to have a lot. Begin by writing the easy ones first, and then the more difficult goals. Use the space below. Now is the best time to begin this goal-writing project.

The happiest people in the world are those who take charge of their lives. People who take action will achieve their goals.

WRITE YOUR ART-RELATED GOALS HERE

Make my living as an artist.

Have a wonderful group of friends who encourage and support me.

Have a good list of people who already own and collect my work.

Now that you have written down your easy and not-so-easy general goals, write down your specific goals for selling art. Say what it is that you want and when you want it. Don't worry about the "how." Hows have a way of taking care of themselves when specific goals have been selected. For example: I want to begin by selling $XXXX of artwork each month. First set short-term goals, and then go on to long-term goals.

ART SELLING GOALS FOR THE NEXT WEEK

Create a daily schedule that includes some time organizing upcoming exhibitions.

Organize a schedule for showing the works I represent for the next three years.

WRITE DOWN YOUR GOALS

The first step to taking action is to write down your goals.

The great successful men (and women) of the world have used their imaginations; they think ahead and create their mental picture, and then go to work materializing that picture in all its details, filling in here, adding a little there, altering this bit and that bit, but steadily building, steadily building.
Robert Collier

161

You may not feel that you are ready to set goals. Go ahead anyway. There is no reason not to. And please don't make excuses like, "I'm too old, too young, not good-looking enough, not smart enough, too fat, too short, too busy, too lazy, don't have enough education" or any other lame excuse you can think of. You know that there are people in all these categories who have achieved unbelievable success.

MY GOALS FOR THE NEXT 30 DAYS

Ask questions of everyone I come in contact with.

Sell more artwork than I ever have before.

Sell $1500 worth of art this month.

Don't hope to achieve your goals—expect to achieve them.

MY GOALS FOR THE NEXT SIX MONTHS

Sell $6000 worth of art over the next 6 months._____

VISUALIZING

It is important to visualize your goals. Picture in your mind what it will be like to achieve your goals. Goals should not be confused with wishful thinking. Goals require commitment. Set your goals, and set about achieving them.

Following is a four-step process for goal-setting that is inspired by Napoleon Hill's "Six Steps to Turn Desires into Gold" as outlined in his book *Think and Grow Rich*.

PROCESS FOR GOAL-SETTING

▸ Write the exact goal. Be specific.

▸ Establish what exactly you are going to give or trade for what you desire—your attention, sincerity, enthusiasm, interest, effort, energy, work, time.

▸ Write out a single paragraph that states clearly and simply the reward or money that you intend to have; name the date by which it will be acquired. State specifically what you intend to give in retuarn for this reward or money, and describe clearly and briefly your plan of action. Keep the paragraph as brief as possible, but do mention all the above points.

▸ Read this written statement aloud, twice daily—once upon awakening in the morning and once just before you go to sleep at night. As you read it, picture yourself already in possession of your reward or money. This is a way to get your goals into your subconscious, where they are powerful.

GOAL-SETTING

When you write down your goals, you will find yourself looking at your life in a different way. You will see yourself as you really are living in the world. You live in the universe, and the universe exists in you. There is an abundant supply of resources for everyone on the planet. It is only our thinking that keeps us limited. What we experience in life is the effect of our thoughts. When you change your thinking, you change your life. Creating goals is the easiest way to change your thinking. You want to live being the cause of your life, not being the effect of the world.

▸ Do not fix your attention on "How." The source of your abundance is your being. The source is infinite. So, set your goals on what you want and need, and on what you can do to make the world a better place.

▸ When writing your goals, be spontaneous and true to yourself. These goals are for you, not for anyone else. You may want to write them down and keep them private. Do everything you can to free yourself and be yourself when you write your goals.

Rowing harder doesn't help if the boat is headed in the wrong direction.
Kenichi Ohmae

"All of the great achievers of the past have been visionary figures; they were men and women who projected into the future. They thought of what could be, rather than what already was, and then they moved themselves into action, to bring these things into fruition."
Bob Proctor

CREATE A SELF-PORTRAIT

Paint a portrait in words. Write a biography for yourself. Pretend that you are listed in *Who's Who in America*. Write out how you want your biography to read later in your life. It should include your education, work experience, the various positions you have held, your main contributions, what you are especially known for, your main achievement, awards that you have received, other ways you have been recognized by your peers, where you live, and any other pertinent details. Edit this biography every year on your birthday.

KEEPING GOALS PRIVATE

When you share your goals with another person, you can dissipate some of your creative energy. It is best to keep goals private. If you are going to share your goals with someone, be sure that she will give you support and encouragement. Better yet, is the person willing to help you move toward your goals in some way?

KEEP YOUR PURPOSE CLEAR

Always keep your goal and your purpose in mind. What is it that you are trying to accomplish? Do you want to sell your works of art, have clients buy from you again and again, or do you just enjoy talking to people? If you know where you are going, it will help you continuously monitor what you say to others.

VISUALIZE SUCCESS

The first step to success in selling art is to be able to see yourself having fun doing that. Take the time to imagine what it looks like. Imagine the pure enjoyment of making people feel great owning the art that you create or represent.

BE AWARE OF YOUR INTERNAL DIALOGUES

Experts say that we are continuously talking to ourselves. We help determine our success or failure by what we say to ourselves. Talk upbeat to yourself. If you tell yourself that you don't like selling art, you won't. Say to yourself, "I love selling this art. It is a wonderful, enjoyable feeling because I love art. It is a ton of fun to sell art. People love art and appreciate having it in their life."

❑ Your goals will manifest in the future.

❑ The best way to establish your goals is to write them down.

❑ Don't make excuses for not setting goals. There are no excuses. Just do it.

❑ Don't worry about how your goals will become reality. The hows have a way of taking care of themselves when specific goals have been selected.

❑ Picture in your mind what it will be like to achieve each of your goals.

❑ Review your main goals often, preferably every morning and evening.

❑ Write a biography of yourself as you would like it to read later in your life.

❑ Keep your goals private. Share them only with people you know will help you achieve them.

❑ Organize your time so that it works for you.

❑ Become aware of your internal dialogues, your self-talk.

CHAPTER SUMMARY

Chapter 14
Personal Psychology

Handling rejection

What you are, speaks so loudly that I cannot hear what you say.
Ralph Waldo Emerson

HANDLING REJECTION

Our duty as men is to proceed as if limits to our abilities do not exist. We are collaborators in creation.
Pierre Teilhard de Chardin

If someone doesn't buy from you, that doesn't mean that you are being rejected. It simply means that he chose not to take advantage of the opportunity you offered. It may be true that if you had used different words, or conducted yourself in a different way, you could have made the sale. More likely, however, no matter what you said, he would not have bought anything.

If you follow just some of the suggestions in this book, sales will happen for you. Every time you make a sale, it will enhance your confidence and the desire to sell more. But how do you handle failure and rejection? Do you get discouraged? Do you want to quit?

Rather than taking rejection personally, let it challenge you to find ways to succeed. Challenge yourself to convert sales resistance into receptivity. Learn to turn a rejection into an opportunity to develop even greater rapport with the client.

Client: "Sorry we have taken up your time. We are just not ready to buy anything today."

Salesperson: "Not a problem. It is really a pleasure to get to know you this afternoon. I enjoyed our time together. I hope that we will have a chance to connect again when you are interested in looking at new works. Please take my card and feel free to call me when you are in town. May I include you on our mailing list? Would you be interested in being our guest at a preshow opening?"

or

"Would you be interested in being a guest at my next open studio?"

or

"Would you like to receive our newsletter?"

People want to feel special, but not pressured. The more you can do that, the higher your rapport will be. If they like you and you follow up with them, they will eventually buy from you. If you can make a strong connection, they will be happy to be on your mailing list, and your follow-up will be welcome. Always consider every rejection just a pause in time before the next sale.

Remember: We want to have loyal clients and collectors who will buy from us again and again. We build a good and loyal client base. Ideally, you want to feel free to ask the people who buy from you for referrals and for additional sales in the years ahead. If you make people feel important, they will like you and want to do business with you in the future.

We are motivated to achieve recognition as an artist and make sales as an art

representative. At the same time, we can be discouraged from taking the initiative in order to avoid failure and rejection.

FEAR

Fear of failure can discourage you from taking action. You have lost nothing. When you do sell, everyone wins. Your clients take possession of the art they love, and you are rewarded with the money you want or need.

Fear is the most powerful negative emotion. We must realize that most fears are unfounded in reality. People want to be liked, admired, and respected. They do not want to cause you psychological pain and suffering. The fear of failure and rejection can cause us to lose enthusiasm, confidence and the desire to move ahead. There is even the expression, "frozen with fear." Fear inhibits our ability to take action, carry out a plan and live our dreams.

TWO KINDS OF REJECTION

There are two kinds of rejection. One hurts our ego, and the other makes us curious or amused.

▸ We can learn to not take rejection too seriously.

▸ We can learn to react with lightness and humor. Never take a lost sale personally. If you do take it personally, you will most likely become disappointed, depressed, defensive, even angry—attitudes to protect your ego.

IMPORTANT PEOPLE

If you are a person who can easily feel that another person is more important than you, then what they say or do can cause you to doubt yourself. Sometimes there is a perceived importance that is prompted by social status, wealth, position in a company or community, age, or sex.

▸ Think of others as equal to you, not above you or more important.

▸ Treat others with politeness, kindness and respect.

▸ We are all important in our own ways.

▸ We are all going to end up the same.

▸ All titles, status and wealth are temporary.

FIRST-NAME BASIS

Many people in our society carry professional titles, such as doctors, dentists, pastors, rabbis, presidents, and senators. In the art business, you may find yourself

Not selling is not failing; it is simply not selling.

face to face with many of these people. A good way to feel comfortable with people you might at first consider superior to you is to address them by their first names. Except in circumstances where you know it is a safe bet to address someone with a professional title or a courtesy title (such as Mr, Mrs or Ms), at least initially, try using the person's first name. For example, if a man introduces himself as Bill Gallo, you would say, "It's good to meet you, Bill." From that time on, he is always "Bill." If and when his wife introduces herself to you, saying, "And I'm Mrs. Gallo," she may add, "but you may call me Cindy." If she doesn't say this, you could ask, "May I call you by your first name?" She then can say, "Yes, you may call me Cindy," or "No, I would prefer you call me Mrs. Gallo."

If a person introduces himself to me as Mr. Smith, I would say, "I'm Robert Dvořák. You can call me Robert; may I call you by your first name?" The person will then say, "Yes, you can call me Will." If a person prefers to be addressed with his or her professional or courtesy title, she or he will tell you.

If you don't feel comfortable using a person's first name, by all means use his professional or courtesy title. Get on a first-name basis from the start whenever you can.

On occasion, a person will call me "sir." Usually it is someone who has been in the military. In that case, I always say, "Please call me Robert."

I would like to stress that addressing people by their first name will go a long way to making you feel connected and comfortable; it will put you on equal footing with that person.

There is one caveat about cultural differences that I, obviously, won't be able to cover with any detail in this book. In some cultures, such as Asian cultures, people who have titles or who are older than you expect you to call them by their professional or courtesy titles.

SELF ESTEEM COMES FROM WITHIN

If we believe that we need to be successful and to be accepted by others to feel good about ourselves, then we will be vulnerable to failure and rejection. Successful people learn how to handle failure and rejection because their self-esteem comes from within—from their own sense of self worth. Whether they fail, succeed, are rejected or loved, they always feel right about themselves.

TIPS

- ☞ Take a negative situation and see what you can learn from it.

- ☞ Consider rejection a pause in time before the next sale.

- ☞ Face your fears straight-on and they will disappear.

- ☞ Be objective in your assessments of failure and rejection.

- ☞ Learn to become resilient.

- ☞ Let failure and rejection ignite your creativity.

- ☞ Listen carefully and remain in the moment.

CHAPTER SUMMARY

❏ Learn to turn a rejection into an opportunity to develop even greater rapport with the client.

❏ The more you make people feel special, the higher your rapport will be.

❏ Remember that your goal is to build a good and loyal client base.

❏ Don't let fear inhibit your ability to take action.

❏ Don't think of others as more important than you.

❏ Don't let yourself be intimidated by people you believe to be important.

❏ When comfortable, address people by their first names.

Chapter 15
Selling Art in Any Economy

Gallery selling

Trading and bartering art

When one door of happiness closes, another opens; but often we look so long
at the closed door that we do not see the one which has been opened for us.

Helen Keller

GALLERY SELLING

In all towns and cities, big or small, new galleries are opening, others are closing, some are changing owners. Having a good reputation as a gallery owner will insure that you stay in business no matter what the state of the economy is. Remember: It is your clientele that keeps your gallery in business, not the economy.

Be sure that you operate with the highest integrity. Treat artists fairly and keep clients happy. It is the gallery owner's reputation to their clients that will make the business successful.

If all you do is hang satisfactory paintings on your walls and wait for people to show up to buy them, a downturn in the economy will end your business. On the other hand, if you have enthusiasm for the art and the artists you show, if you show a variety of works, if you like people and want to make people feel special, are willing to network, advertise carefully, have regular shows, keep your doors open at convenient times, and employ people who love art as you do, no matter what the economic times are, you will prosper. Here are some ways to do this:

Individual artists can use these tips towards their own success too.

- ▶ Get to know your clients.
- ▶ Always ask for referrals from clients who buy from you.
- ▶ Follow up all leads.
- ▶ Feature living artists in your gallery who have dedicated their lives to their art—artists who are in it for the long haul.
- ▶ Maintain an up-to-date web site that is beautifully designed and easy to use.
- ▶ Answer e-mail and phone inquiries promptly.
- ▶ Get to know your artists, and pay them promptly.
- ▶ Feature and promote deceased artists.
- ▶ Listen and ask questions.
- ▶ Don't try to educate your clients unless they ask you to.
- ▶ Budget your advertising carefully.
- ▶ Write articles for art magazines and take out an ad in the issue that features your article.
- ▶ Keep long hours and stay open through thick and thin.
- ▶ Develop an eye for quality and innovation.
- ▶ Develop the ability to build and maintain trust.
- ▶ Learn how to create the desire to own. (See Chapter 8.)

▸ Believe in the importance of art and artists.

▸ Get your name on donor lists. Give to support the arts.

▸ See the art business as honest, fun and rewarding for everyone who is engaged in it—artists, clients, gallery owners, gallery employees, framers, and nonprofit organizations that support the arts.

▸ Don't sell art for investment.

▸ Understand and use the ABC's of human relationships. (See Chapter 3.)

▸ Be creative. Find new ways to get people to notice what you are doing.

At one time I had my work in a wildly successful gallery on a busy street loaded with stock brokers and investment counselors. I'd still be dealing with him, but the beautiful fellow passed away. On a day when the stock market retreated 508 points (October 19, 1987), he phoned to say he had sold five paintings of mine. I was amazed. "Yep," he said. "When stock brokers have lots of money, they collect art. And when stock brokers have only a little money, they invest in it. It's human nature.
Robert Glen

TRADING AND BARTERING ART

Trading art for money—selling art—is the most common way sales take place, but not the only way. When the economy is down, trading or bartering art is a good way to keep money in your pocketbook. If you can trade art for things you want or need, you will have more money to spend on other necessities.

Art is often traded between galleries and dealers, and between artists at art fairs. Art can also be traded for goods and services. An additional advantage to making a trade is that even more people will see your art. The more your art is seen, the more it will be in demand by new buyers.

If you are an artist who is just starting out, you may want to consider using your art as currency to buy goods and services that you need. There are many businesses that are happy to acquire art they admire in exchange for the goods or service that they sell. This is especially true with independent business owners. Keep an open mind. Whenever an opportunity comes up, ask! Remember Hank Trisler's advice: "Ask and you get, don't ask and you don't get." It never hurts to ask. The question is free.

Here is a list of some of the trades I have made over the years with my own paintings and prints:

- Accounting and tax service
- Art from other artists at street fairs
- Brochure
- Car repair
- Chiropractic care
- Consulting services
- Copy machines
- Copy paper
- Service contract for a copy machine
- Dental work
- Dog training lessons
- Food and catering service for an open studio event
- Furniture repair
- Paint job for my car
- Pillows
- Printed Christmas cards

Keep your shop and your shop will keep you.
Benjamin Franklin

- Printing services
- Professional photography for publicity
- Secondhand flute
- Show invitations
- Slippers, handmade by an artist
- Studio rent

You can see that these trades vary considerably. Over the years, these trades have added up to significant savings. I am very grateful to all of the individuals who love my work and want to own it in exchange for the goods or service that they provide to me. You might be surprised, as I have been on many occasions; I have asked the question and gotten a positive answer. The question is:

Art rep: "Would you consider trading art for........."

Client: "Why, yes, what have you got?"

The client can always say no, and then you must decide whether you will pay for the goods or services with money, do without the purchase, or try trading with another business for the same thing.

SALES TAX

Be sure that the sales tax is always paid when you make a trade. According to the California State Board of Equalization, when a trade is made, there is always a buyer and a seller. The seller must pay the sales tax on the selling price in dollars. The trade is entered in the books as a dollar amount. If a wholesale trade is made, there is no sales tax because the items are exchanged for resale.

CHAPTER SUMMARY

❑ Consider trading your art for goods or services whenever you can.

❑ Always ask. The person can either say yes or no. The question is free.

❑ Remember that a trade is just as good as a sale. It is money that you won't have to spend.

❑ Be sure the sales tax gets paid in a barter.

Chapter 16
Finding an Art Gallery

Selecting a gallery
Courting a gallery

Every artist ought to be an exhibitionist.
Egbert Oudendag

SELECTING A GALLERY

Many artists think that all they need to do is to find a gallery to sell their work and all their worries will be over; the gallery will do everything for them. That may be true for a very limited number of artists, but most of the artists I know who are selling their work have learned that, "If it is going to sell, it is up to me."

Here are some of the problems I have personally had with galleries:

▸ Didn't pay me promptly for work sold

▸ Made deals to sell for less without my approval

▸ Never paid me for certain consigned paintings that were sold

▸ Didn't return consigned artwork they didn't sell

▸ Went out of business and closed their doors without returning my work

▸ Lost or kept my slides

▸ Lost my work

A well-known and highly regarded art gallery owner in San Francisco went bankrupt. It was rumored that it was because of unwise real estate investments by the owner. He covered the windows and closed the doors of the gallery. He had many large works by several artists, including my own. I went to the gallery a number of times to retrieve my work. I could hear people talking inside, but no one would answer the door. Finally, a number of us went to the San Francisco Lawyers for the Arts to get help. They made legal arrangements for the gallery to open its doors to the artists it represented on a Saturday morning. Luckily, we were able to reclaim our work.

If you are an artist who wants to work with a gallery to supplement your sales, do your research. Visit the galleries that are geographically close to you, and find the ones that would most likely want the kind of work you create. Find out about the gallery's reputation: Take the time to talk to other artists represented by the gallery. Reputable gallery owners will be glad to have you talk to their stable of artists, as well as other art galleries in the vicinity. The art world is not that big. Word quickly gets around if a gallery does not pay its artists in a timely manner or has other problems.

COURTING A GALLERY

Court the gallery you've selected. Go to the openings, talk to the owners, get them interested in seeing your work. If you have been promoting yourself locally through fundraising events and shows in public and corporate spaces, the gallery owner will most likely have heard your name and possibly even seen your artwork.

When you make an appointment to show your work, be sure to remember that you need to "sell" your artwork and yourself to the gallery, just as you would an individual client buying a piece from you. Develop rapport, listen, ask questions, pause, test close and close. If the gallery is interested in working with you, ask what paperwork is required for you to proceed. Many galleries will just give you a consignment form listing work you are leaving with the gallery, with the wholesale and retail prices.

STAYING IN TOUCH WITH YOUR GALLERY

Once you begin a relationship with a gallery, be sure to stay in touch. Visit the gallery often, even if it is just to say hello. Stay in communication with them.

- Let them know that you are interested in doing all you can to make their job easier.

- Let them know that if they send you referral clients to your studio space, you will give them their commission from sales you make to these clients. The first time you give them a check for a sale from a referred client, you will gain their respect and trust.

- Encourage them to bring clients to your studio.

- Give them high-quality photographs and a well-written bio and statement for publicity purposes.

- Be sure that your work goes up on their web site.

CHAPTER SUMMARY

❏ Never believe that all you need to do is find a gallery to show your work. This will be just one opportunity among many that you, as an artist, can take advantage of.

❏ Before you contact a gallery, do your research.

❏ Remember that you need to "sell" your artwork and yourself to the gallery, just as you would an individual client.

❏ Once you begin a relationship with a gallery, be sure to stay in communication with them.

Chapter 17
Resources

Rental/lease agreement

Client profile chart

Client information sheet

Communication log

It is our attitude much more than our aptitude that will determine our success.

RENTAL-LEASE AGREEMENT

Renter/Leasor _____

Address _____

City/State/Zip _____

Telephone _____

Artist/Agent _____

Address _____

City/State/Zip _____

Telephone _____

TERMS AND CONDITIONS

1. Rental/lease period is three (3) months. Artwork may be re-rented successively for one year, at which time it must be purchased or returned. _____ percent (___%) of rental fees can be applied to purchase price. Renter agrees to handle carefully and return on due date or pay overdue charge of $_____ per day. Rental and renewal fees are payable in advance.
2. Renter/leasor shall be responsible during rental term for loss or damage to said property from whatever cause, including fire and theft. Artwork may not be painted or altered. Artwork may not be transferred to another person's care.
3. At the expiration, termination or default of this Rental/Lease Agreement, renter/leasor agrees to return said property to artist in original condition.

Title _____ Medium _____ Size _____

List any abnormal condition of work here: _____

Start date _____ End date _____ Rental Fee _____ Sales Price _____

This agreement is subject to the terms and conditions above.

ARTIST _____ DATE _____

RENTER/LEASOR _____ DATE _____

CLIENT PROFILE CHART

Name _____

Address _____

Work phone _____ Home phone _____ Cell phone _____

Referred by _____ Age _____

Single/married/divorced _____ Spouse's name and age _____

Children and ages _____

Pets _____

Occupation _____

Education/income level _____

Type of furnishing/home style _____

Subject matter _____ Colors _____

Style/type of work _____ Size/medium preferred _____

Needs/wants _____

Intended use _____

Last contact date by phone _____

Last mailing _____

Needs information on _____

Other follow-up needs _____

Date	Price	Size	Medium	Title/Description	Use

CLIENT INFORMATION SHEET

Name

Address

Work phone Home phone Cell phone

Referred by Fax Best time to call

Date	Reason for contact	Commitment date	Action taken	Next date

Communication log

Date	Time	Notes		Follow-up

Robert Regis Dvorák, FAAR, paints in watercolor, oil, and acrylic, with a studio at the Sanchez Art Center in Pacifica, California. His inspirations are the California coast, Hawaii, Yosemite National Park, Europe—particularly Italy and Greece—and the human figure. His watercolors and oils are shown at the Garden Gallery in Half Moon Bay, California, the 20th Street Gallery in Sacramento, The Village Gallery in Maui, and the Nohea Galleries in Honolulu, Hawaii.

Mr Dvorák also teaches drawing and watercolor classes for University of California Extensions, San Francisco State University's College of Extended Learning, community colleges in California and Hawaii, and the University of Hawaii. He taught architectural design and drawing and watercolor painting at the University of Oregon for seven years and at the University of California at Berkeley for two years.

Mr Dvorák has written and illustrated the following books: *Drawing Without Fear*, *The Magic of Drawing*, *The Pocket Drawing Book*, *Experiential Drawing*, and *Productivity at the Workstation*. He has illustrated two guidebooks: *Half Moon Bay Exploring on the North Central California Coast* and *Monterey Peninsula Exploring* by Nancy and Neil Evans. Robert and his art were featured in two articles in *American Artist Magazine*: *Sketching While Traveling in Greece* and *Twenty Minutes to a Beautiful Figure*.

Mr Dvorák received his Bachelor of Architecture degree from the University of Illinois and his Master of Architecture Degree from the University of California, Berkeley. He was a recipient of the American Academy in Rome Fellowship (two years), two grants from the University of Oregon, and a grant from the California Arts Council to promote art in California schools. He has produced more than 20 short experimental films; many have been featured in film festivals in the US, Europe, and Australia.

Mr Dvorák has had 22 one-man exhibitions of his work. He is primarily a painter but also works with life drawing and as a print maker (etchings and woodcuts). His paintings, films, and prints are in many private and museum collections.

Mr Dvorák has traveled in 54 countries. He has celebrated Carnival in Trinidad; worked as a caricature artist in Japanese night clubs; explored over 10,000 miles of India; bicycled around the Zuider Zee in the Netherlands; investigated the ruins of Angkor Wat in Cambodia; traveled on the Transiberian Railroad; hiked the Great Wall of China; climbed to the top of the Great Pyramid in Egypt; and sailed the Greek Islands.

Mr Dvorák is often invited to be a keynote speaker and sales trainer, drawing on his many experiences to illustrate his message that every person has the power to see and create his or her life.

Reproductions of a few of his works can be viewed on his web site at www.youcreate.com.